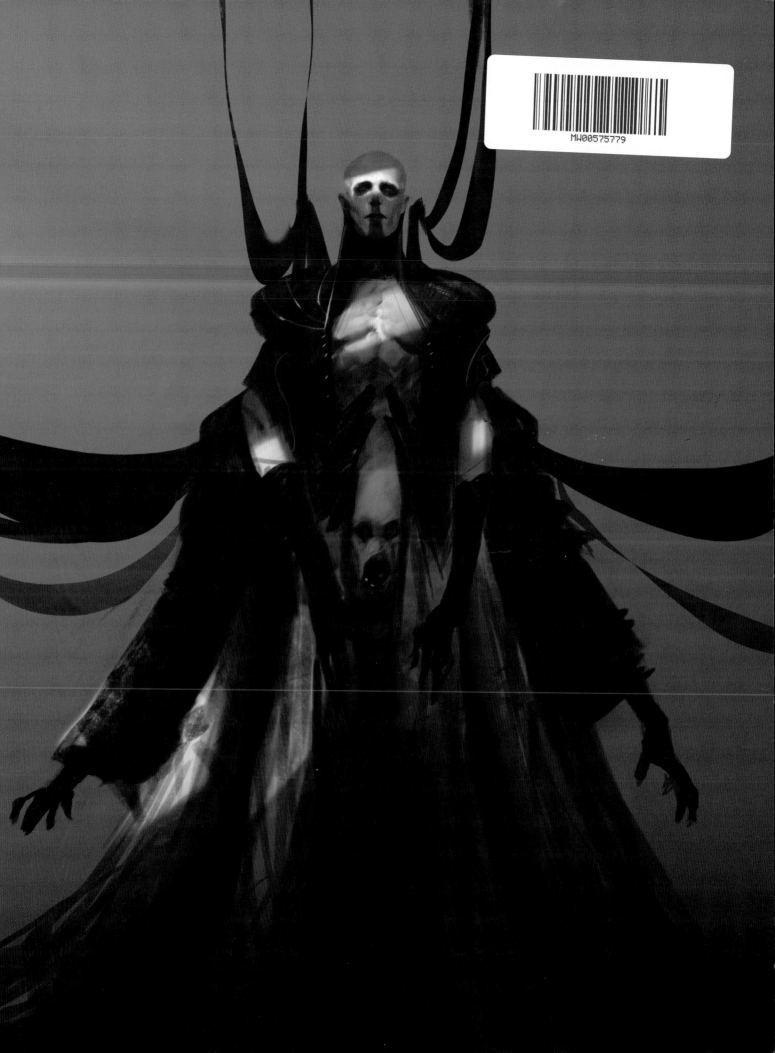

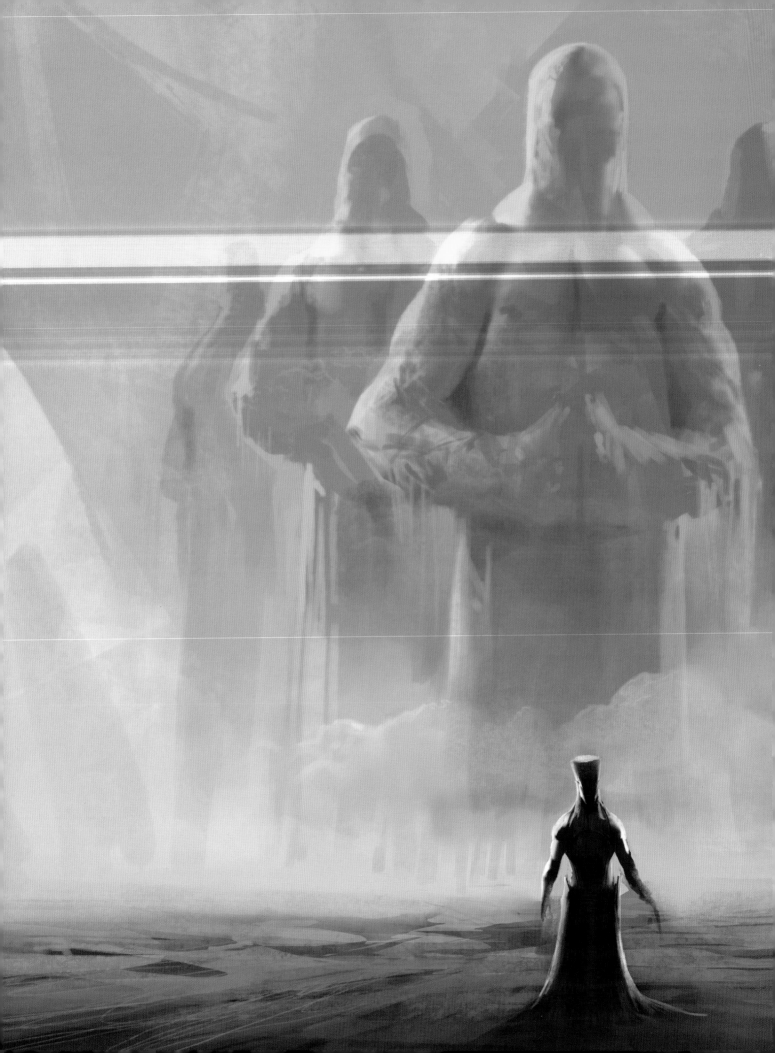

HEAVEN'S HELL

THE ART OF ANTHONY JONES

designstudio|PRESS

HEAVEN'S HELL
THE ART OF ANTHONY JONES

Design Studio Press
8577 Higuera Street
Culver City, CA, 90232

Website: www.designstudiopress.com
Email: info@designstudiopress.com

Editor: Teena Apeles
Graphic designer: Christopher J. De La Rosa and Alyssa Homan
Art director: Scott Robertson

10 9 8 7 6 5 4 3 2 1

Printed in China
First edition, September 2015
Hardcover ISBN: 9781624650017
Library of Congress Control Number: 2013935807

FSC
www.fsc.org
MIX
Paper from responsible sources
FSC® C016973

DEDICATION

To all my supporters and backers, thank you from the bottom of my heart.

It is very important to me that you all understand the power of your support. It not only gave me the ability to start this project, but it also put me in the mindset that I was able to do anything I put my mind to. Not everyone has this opportunity, and I am tremendously grateful to each of you.

I am not only going to support the things you do from here on out, I will always be available if you need help staying motivated and moving forward. For some of you I have done this already, to the rest of you, I look forward to hearing from you.

I have been striving to open doors and create pathways for aspiring artists by finding ways to make the art world more accessible. I've made mistakes and I've had triumphs, and all of this I want to share with all of you.

Don't let the overwhelming pressure to succeed weigh you down, or allow depression and lack of motivation to hold you back. With time, you can achieve all that you want.

Thanks for everything, and I can't wait to see what I can do to return the favor.

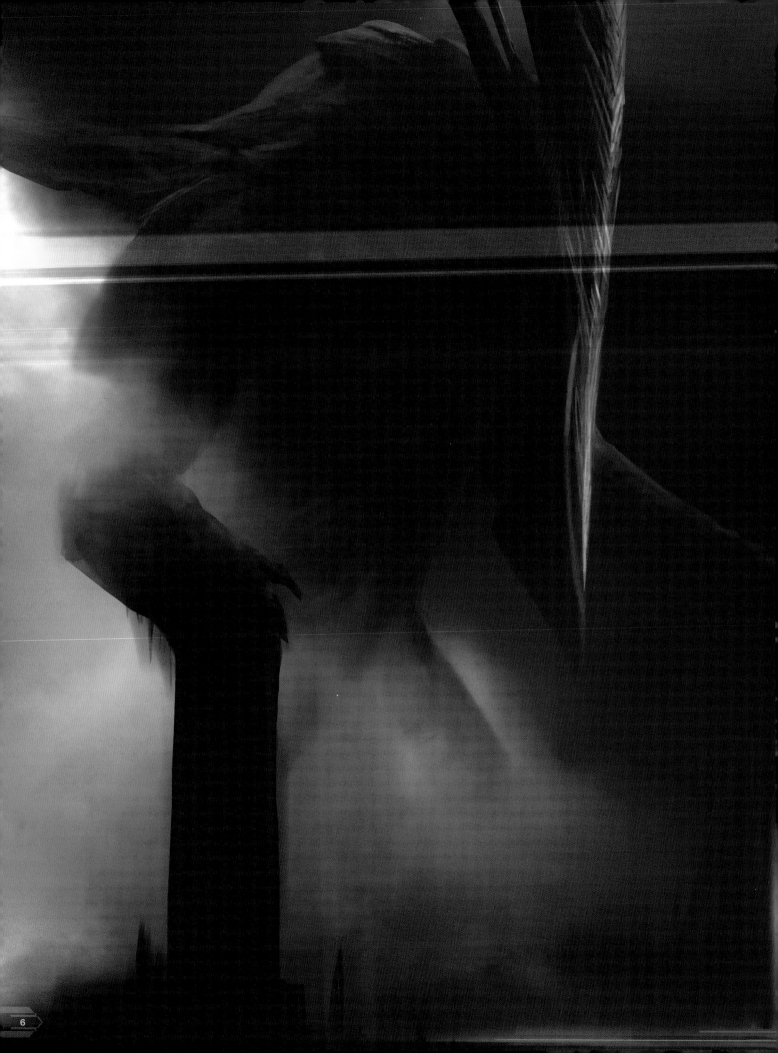

CONTENTS

FOREWORD

Several years ago, Anthony reached out to me to discuss the process of creating an intellectual property (IP). Having just finished my first book, *Last Man Standing*, I warned him that wanting to create an IP is one thing, but ultimately completing the project is another.

When we met, Anthony was full of energy. He spoke about where he had come from, not only as a person but also as an artist. He didn't flaunt who he was or what he had done, but what he wanted to accomplish. Despite the horror stories I relayed to him about producing a book, Anthony still wanted to do it.

Now, let's be honest. If you're reading this, or are in the art business, we aren't real-life heroes. We sit in our offices or studios and design creatures, monsters, space marines, and other weird and strange characters. We're not saving lives. And Anthony wasn't about to traverse into a life-or-death situation—he was simply making a book.

However, what I couldn't brace Anthony for was the mental journey he was about to embark on. When we finally honed in on what he wanted to accomplish, he explained that he wanted to build a world. To design and create a world, you must be willing to take a part of yourself and weave it into the story. You must constantly be on your feet, thinking of each step your character will take and where your story will unfold.

The first part of making a book is simple. You're allowed to fill empty, endless pages with your imagination. At this stage, there are no rules or guidelines unless you write and define them. But, at some point, everything begins to close in on you, and soon you might begin to question if all those choices you made are now the correct ones. Mental games of doubt and insecurities set in, and thoughts of readers potentially not enjoying it, or you yourself not fulfilling what you set out to do, begin to creep into your mind. If you allow such thoughts to overwhelm you, your projects may fall apart and fade away.

When Anthony showed me the final book, he had done quite the opposite. I could write all day about what's before you, but I'd much rather you enjoy it for yourself. What I find even more inspiring than the work in this book is the fact that Anthony followed his gut and ultimately found his light at the end of the tunnel.

That's what being an artist is all about.

Dan Luvisi
Summer 2015

INTRODUCTION

Heaven's Hell is my idea of what the afterlife could be—both heaven and hell.

A few years ago I started to visualize what characters exist in the afterlife and began to put them down on paper (digital paper, but you get my point): humans residing alongside creatures from foreign lands. Next I started to think about the external and internal struggles of these characters. I asked myself, what motivated their actions? I'm not a religious person, but the laws of religions fascinate me, so I developed "scriptures" to govern the behavior of some of these characters in order to further explore this world. My goal with this book isn't really to tell a story—yet—but to show bits of the afterlife I've envisioned and introduce the striking, yet melancholy, beings who inhabit it.

I put together a Kickstarter project in 2013 to help me produce a series of digital paintings for the book, but more so to see if others would be interested in my demented visions of the afterlife. Sure enough, others were. My initial goal of $9,000 was met in the first 24 hours, and after a month I received a total of about $55,000. I plan on developing this world further, but one step at a time. I find myself getting overzealous and pushing myself too much too fast.

From the beginning, my fans have been supportive, and with every delay, I would get an equal amount of patience and reservation. I appreciate all who have backed me in this project, and I look forward to future adventures with you. Now go enjoy the book, and start dreaming up your own nightmares.

Anthony Jones
Summer 2015

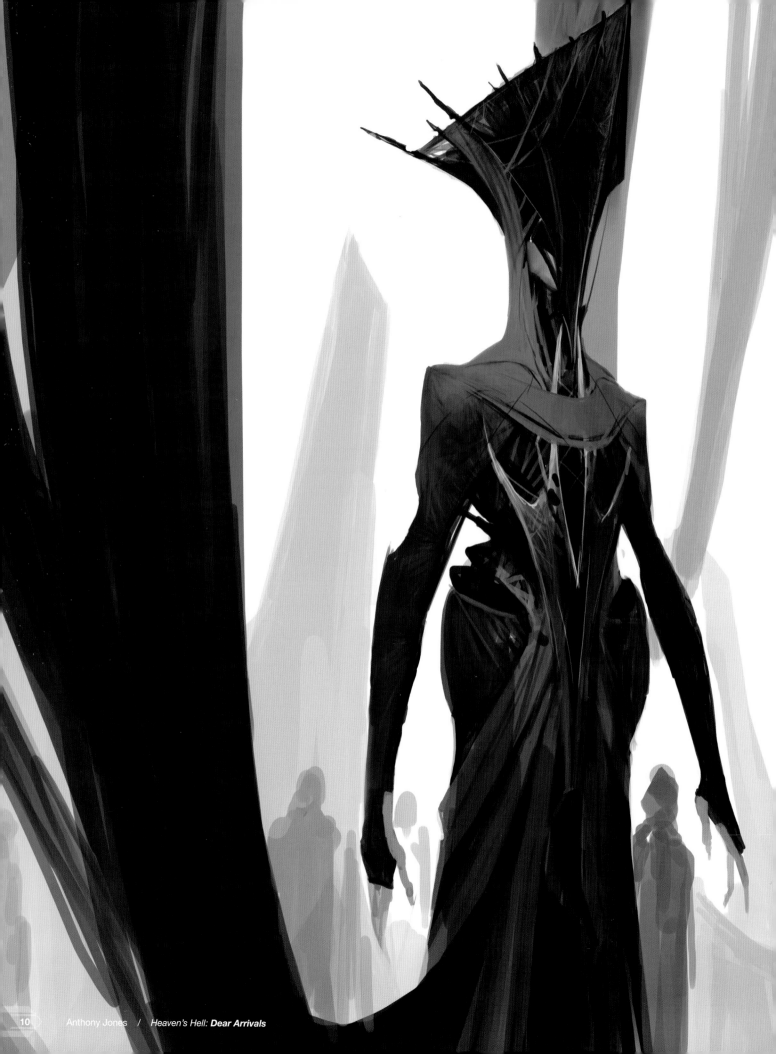

Anthony Jones / *Heaven's Hell: Dear Arrivals*

DEAR ARRIVALS

Welcome, we've been waiting.

It may feel strange to find yourself in this bleak place, and, I assure you, it's as horrifying as you imagined. But don't despair . . . I'll serve as your guide.

First, let's get one thing out of the way: you are dead. And this world is the domain of the gods. But, you can join them—and in the most glorious of ways—on the battlefield of the heavens. There you will meet the fiercest factions you'll ever encounter: the sisters of Haliled and the brothers of Jisais. Know that they, along with the Sages, can lead to your undoing or rebirth.

Hence, always be on guard, for you have descended into afterlife, and there are only two ways out: to pass from this world into true death, or to be born again.

Yours in death,
Deols, Crimson Sage

THE CRIMSON SAGES

Bringing truth and order to all in the afterlife, the Crimson Sages believe the universe is governed by predestination, with the gods preordaining every cosmic tick. There was a beginning and there will be an end to all things. Rebirth only comes to those whose fate is to live again.

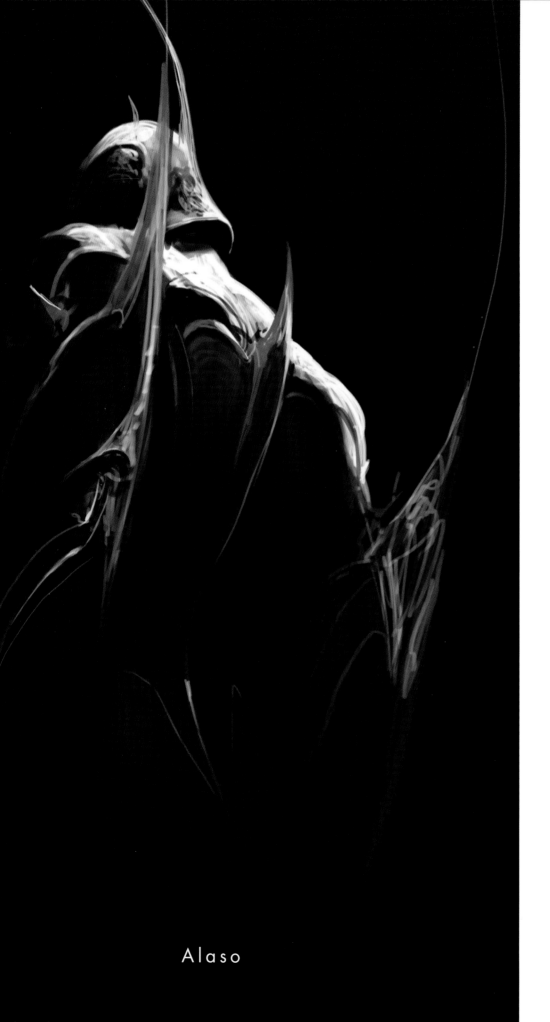

Alaso

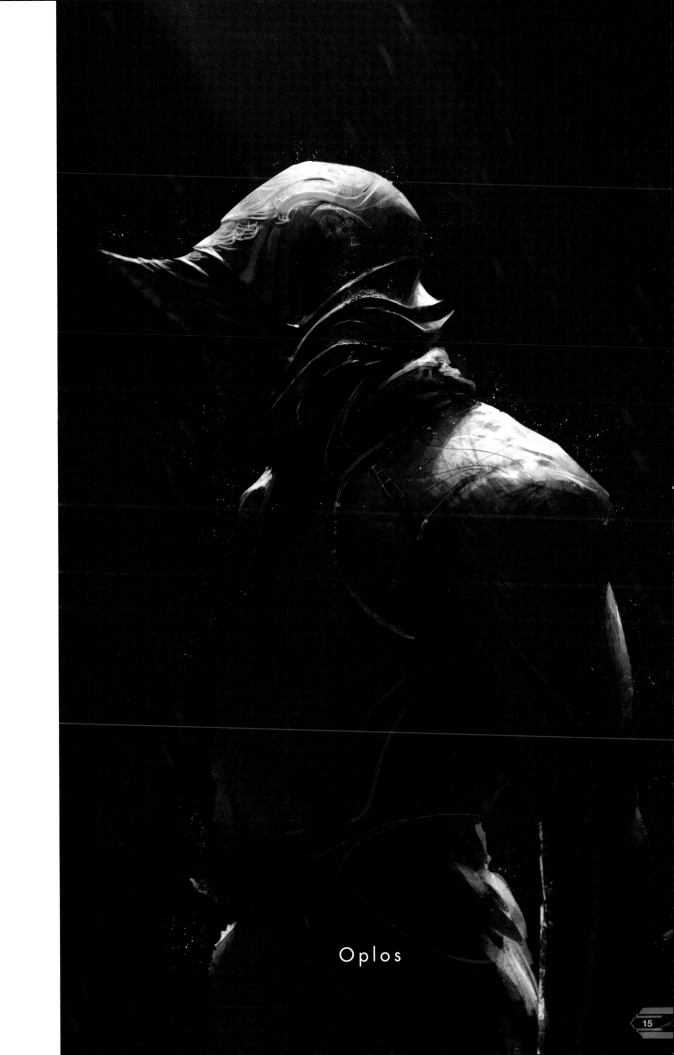

Oplos

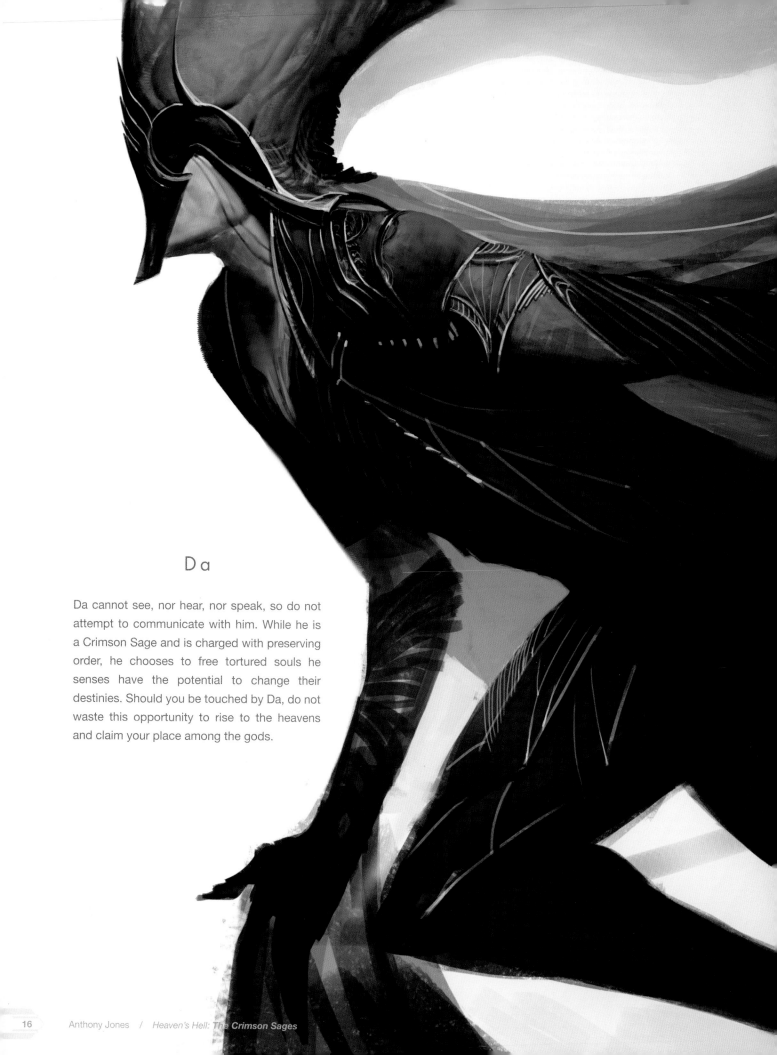

Da

Da cannot see, nor hear, nor speak, so do not attempt to communicate with him. While he is a Crimson Sage and is charged with preserving order, he chooses to free tortured souls he senses have the potential to change their destinies. Should you be touched by Da, do not waste this opportunity to rise to the heavens and claim your place among the gods.

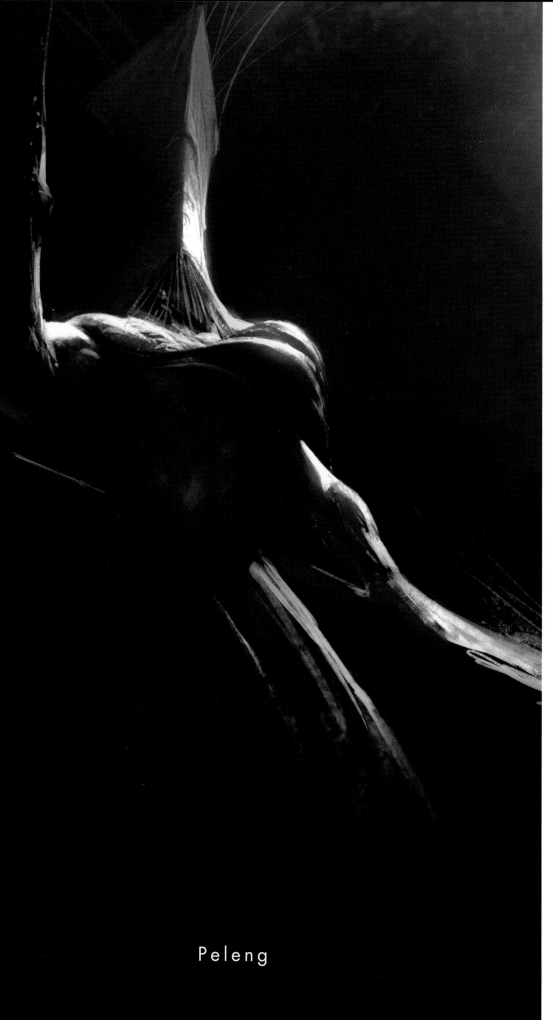

Peleng

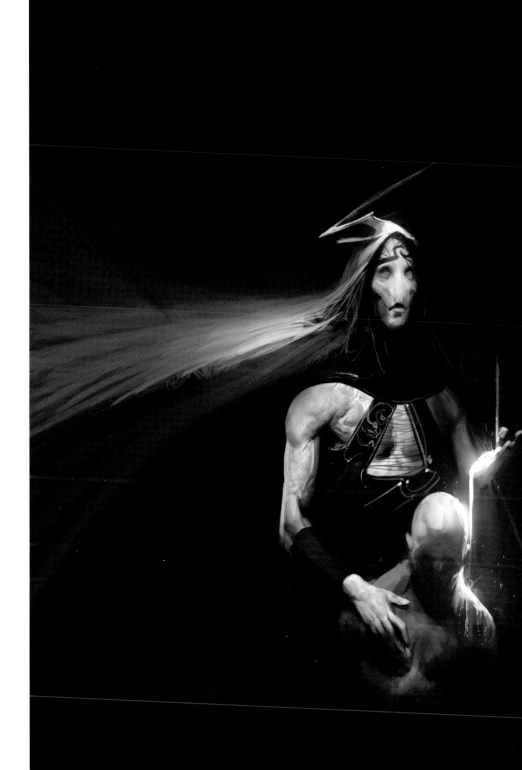

The Healer

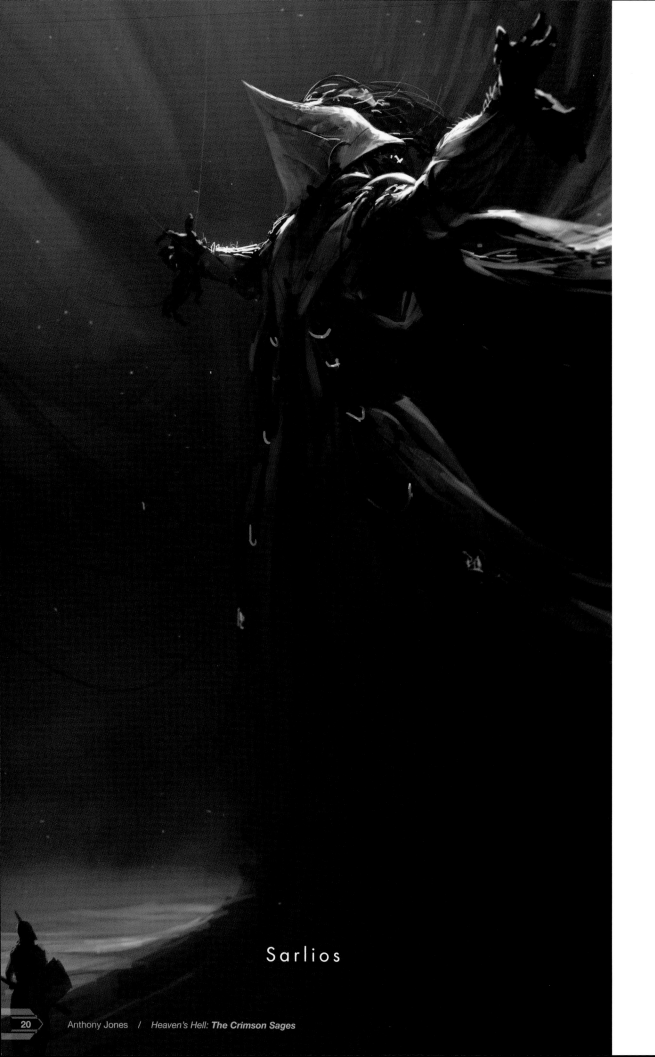

Sarlios

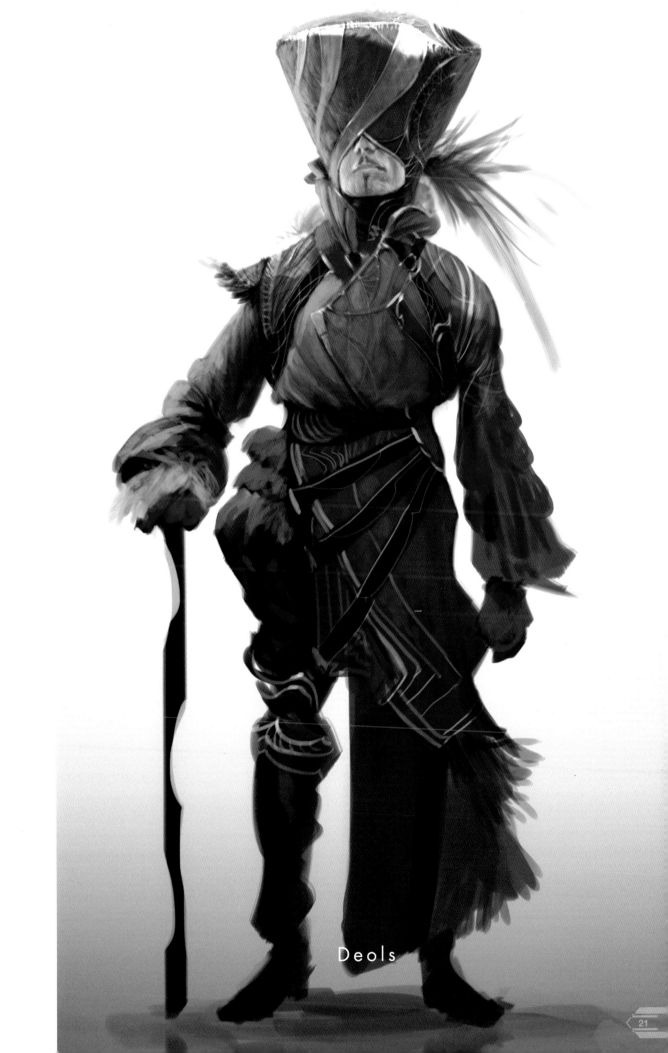

Deols

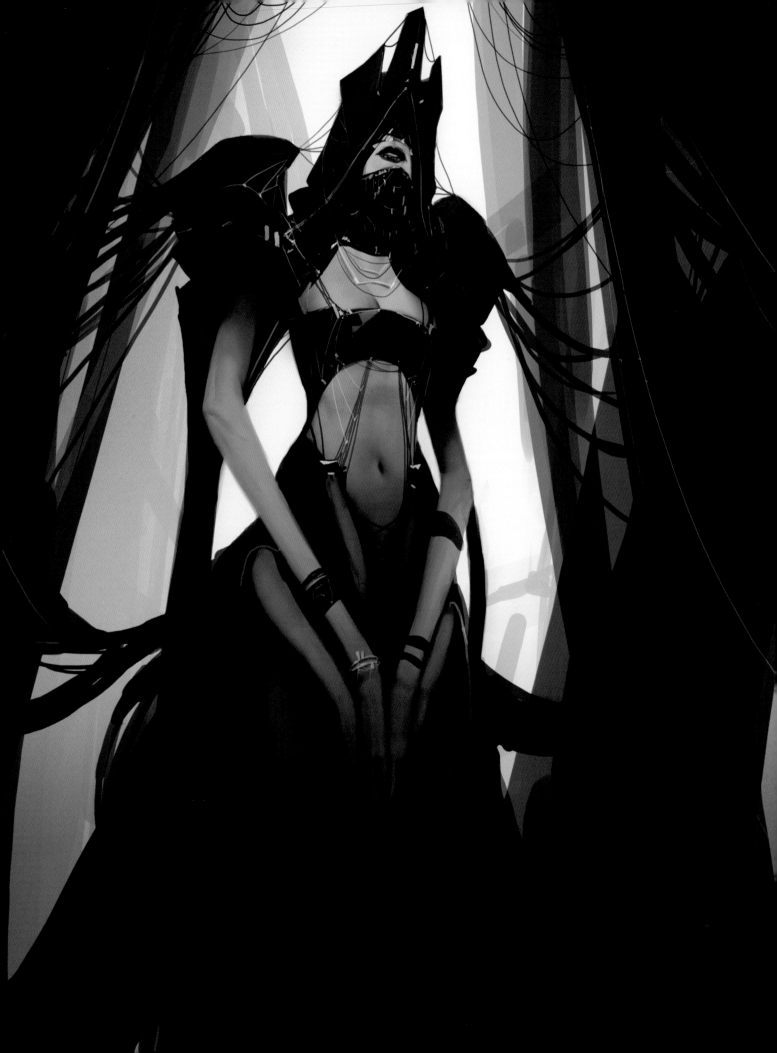

THE SISTERS OF HALILED

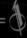

To sacrifice one's mind to follow one's heart is a fool's game.

If thou seek love, thou seeketh tragedy. Such pleasures always come to an end; whether it be by death or loss, love always comes to an end.

What follows is abandonment, pain, fear, and loneliness. To prevent such tragedy, obey your mind fully. The heart is a liar. These are the teachings of Haliled herself.

You must let go of all you love to be a true sister of Haliled, cleansed of this idiocy. Greatness could never be achieved with such weakness.

If thou seek a better life, a life beyond the afterlife, do not love.

The allure of Haliled and her sisters is undeniable. Wielding what they consider their most powerful weapon, beauty, Haliled's sisters are quite skilled at defeating their adversaries, whatever sex they may be, by targeting their greatest weakness: their desire for love.

For while love is seen as a magical thing that mystifies all who live in the cosmos, Haliled sees no value in it—only the tragedy that follows it. For her, to be a worthy contender for rebirth, you must eliminate such idiotic pursuits.

THE SISTERS OF HALILED INSTEAD FIND PLEASURE IN LOVE'S DEMISE.

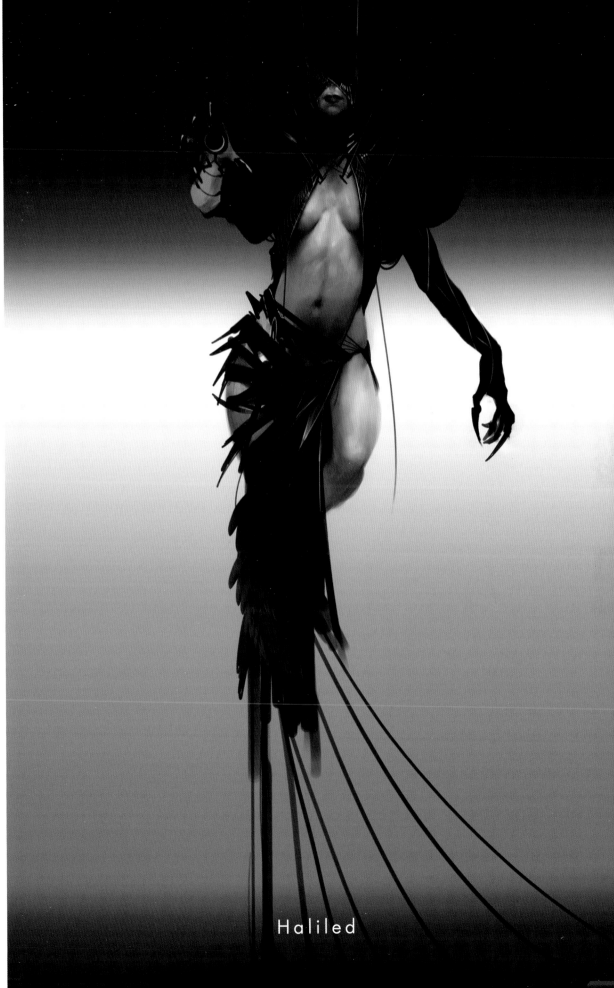

Haliled

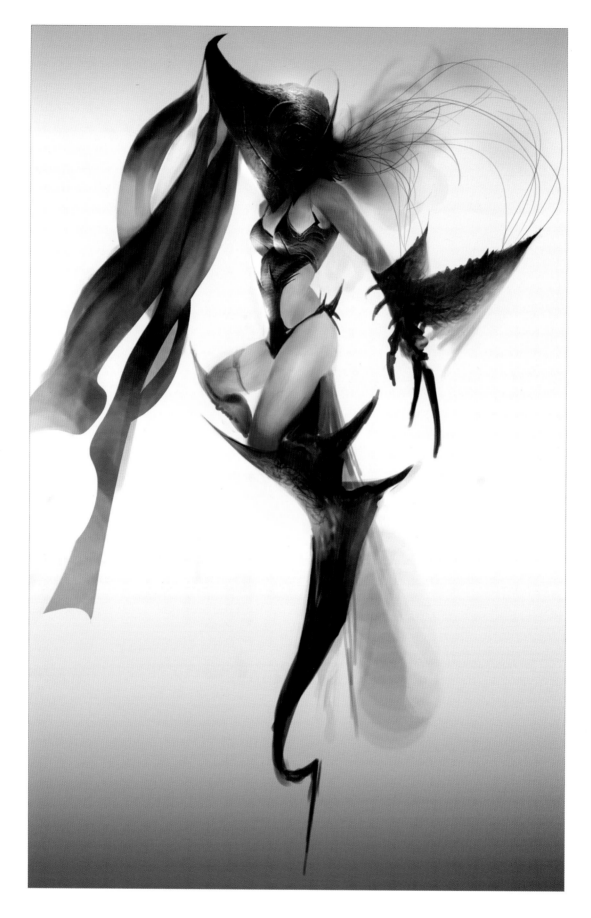

Darlsolos Slave

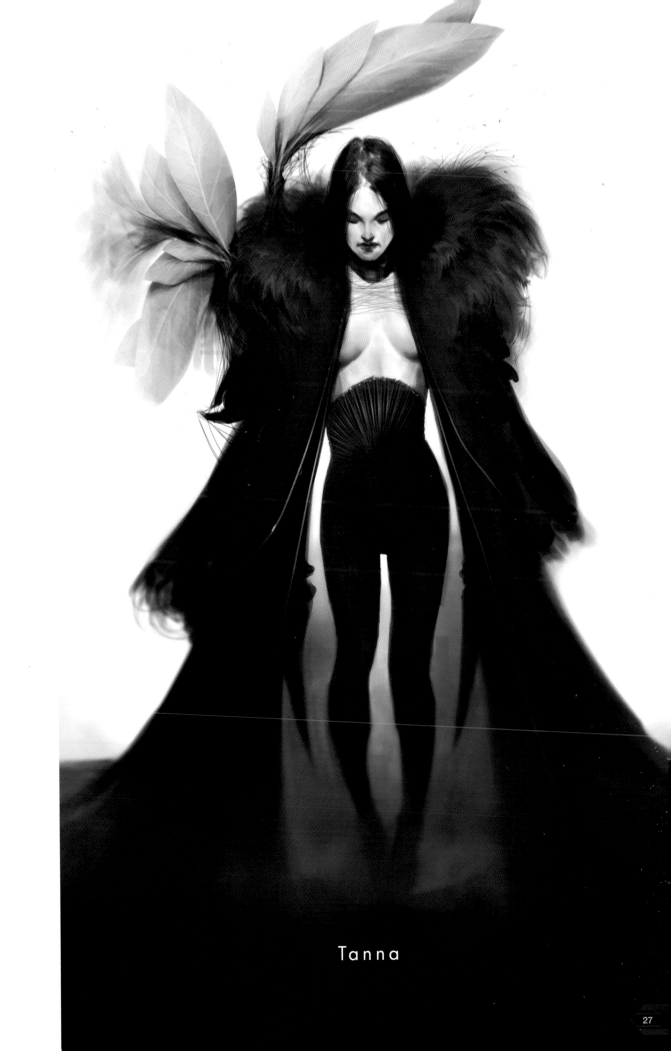

Tanna

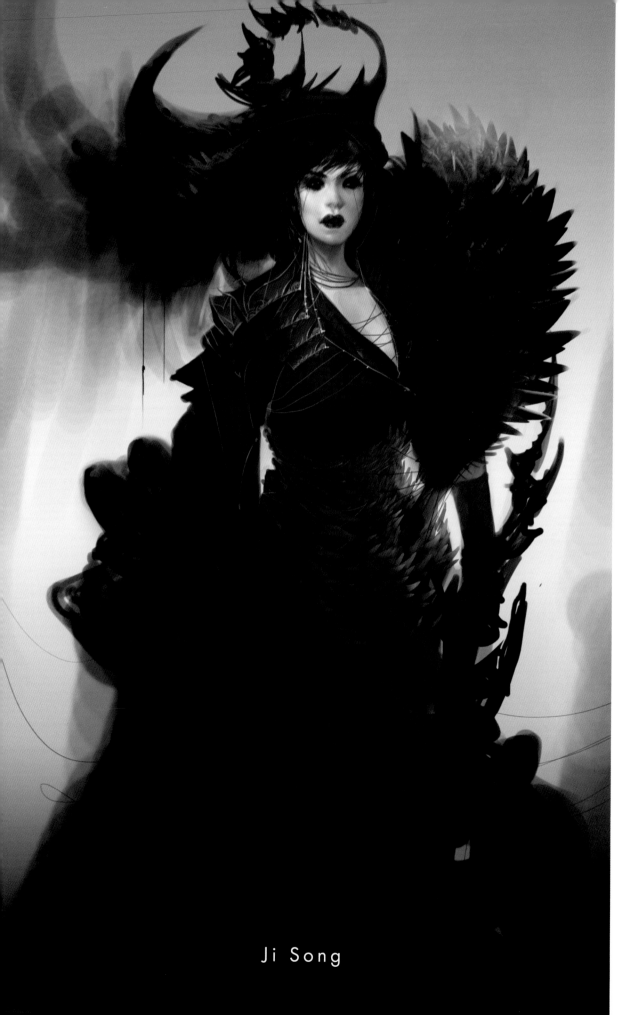

Ji Song

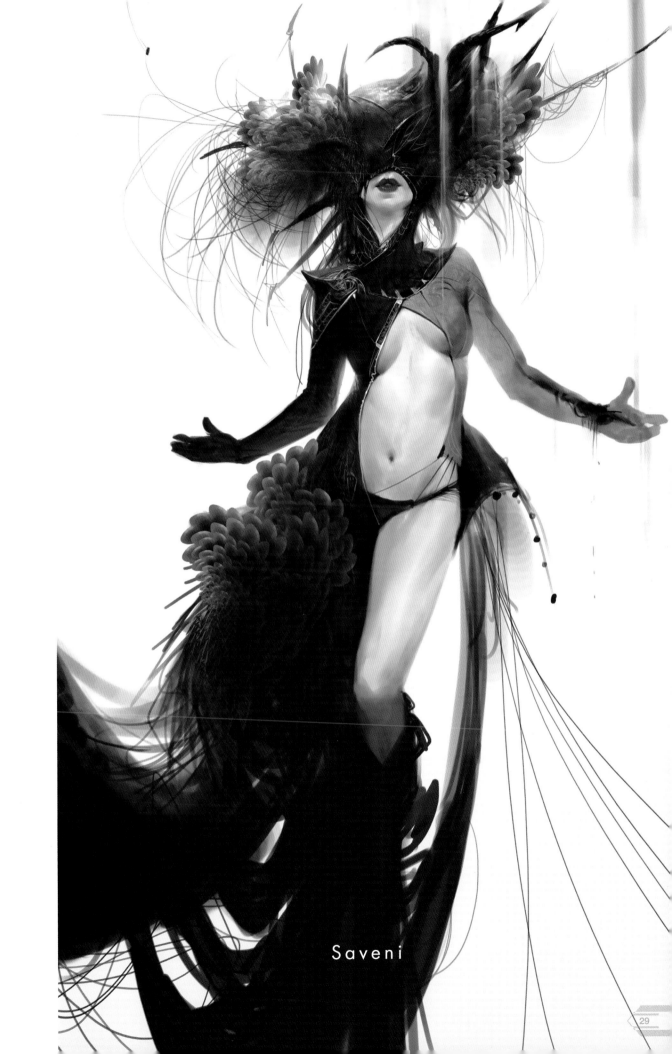

Saveni

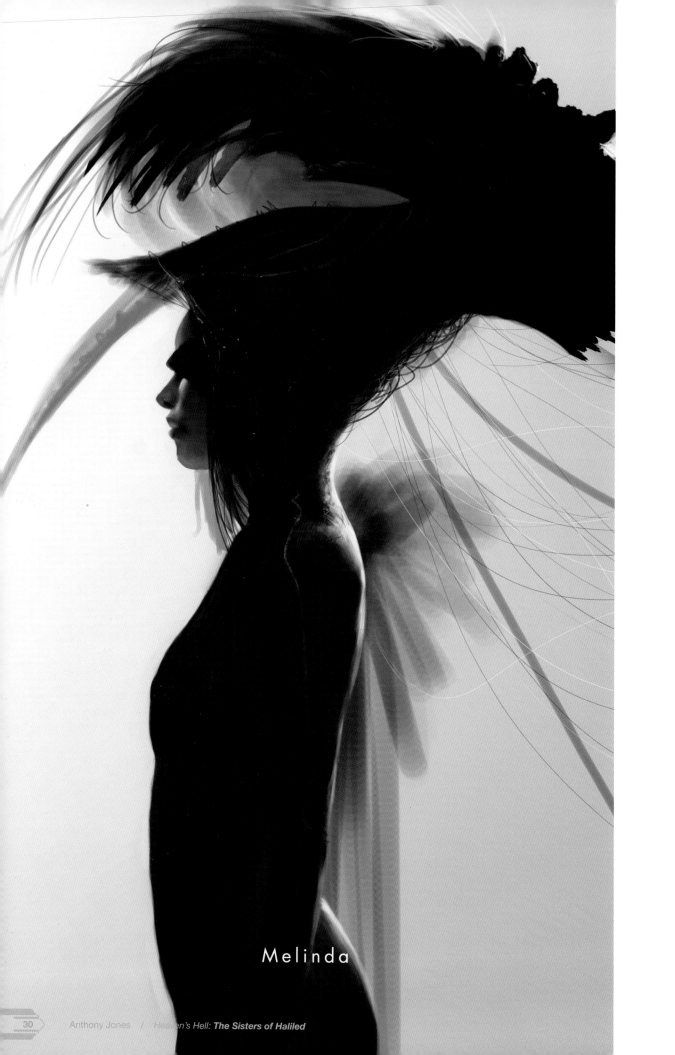

Melinda

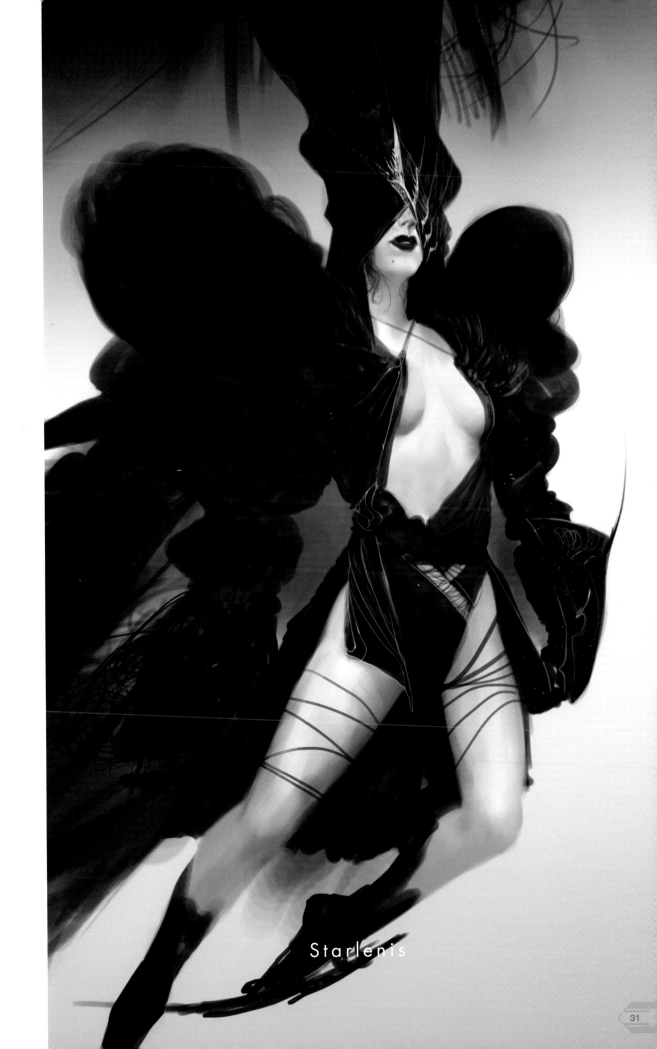

Starlenis

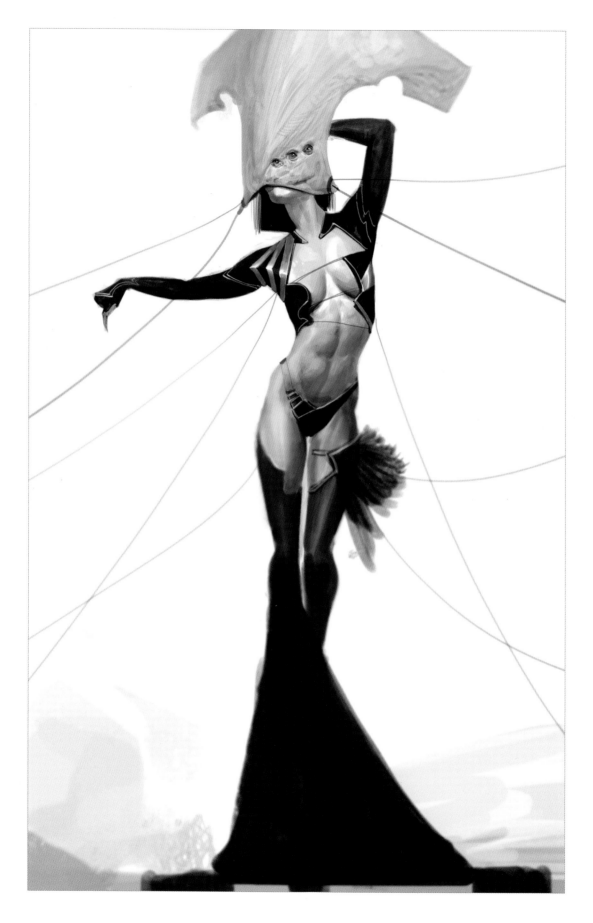

Yuansi

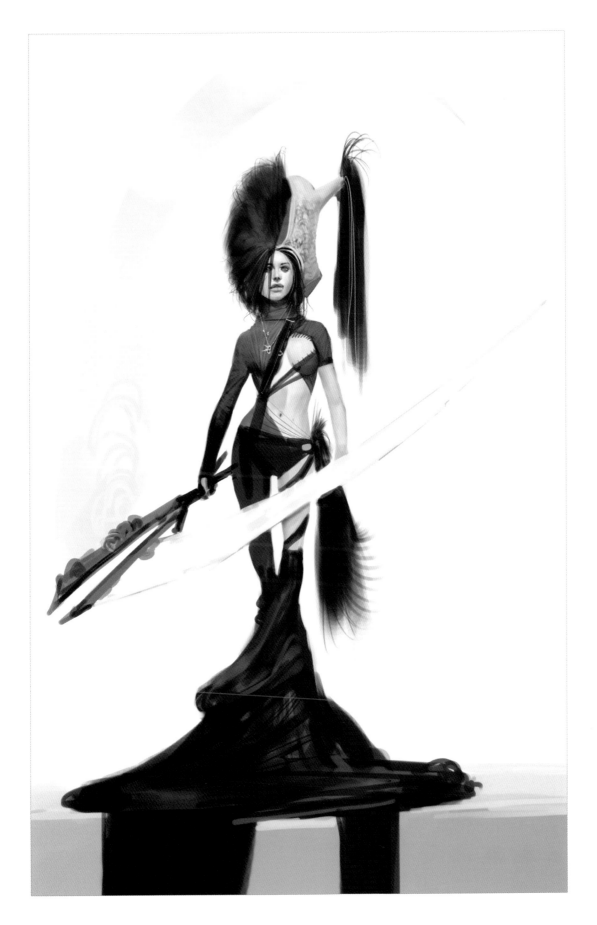

Uris

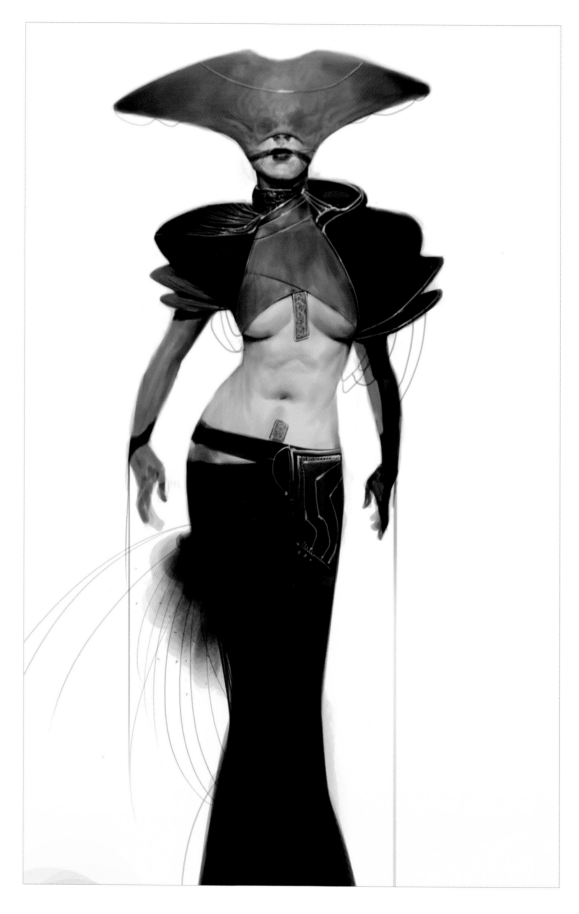

Alleb

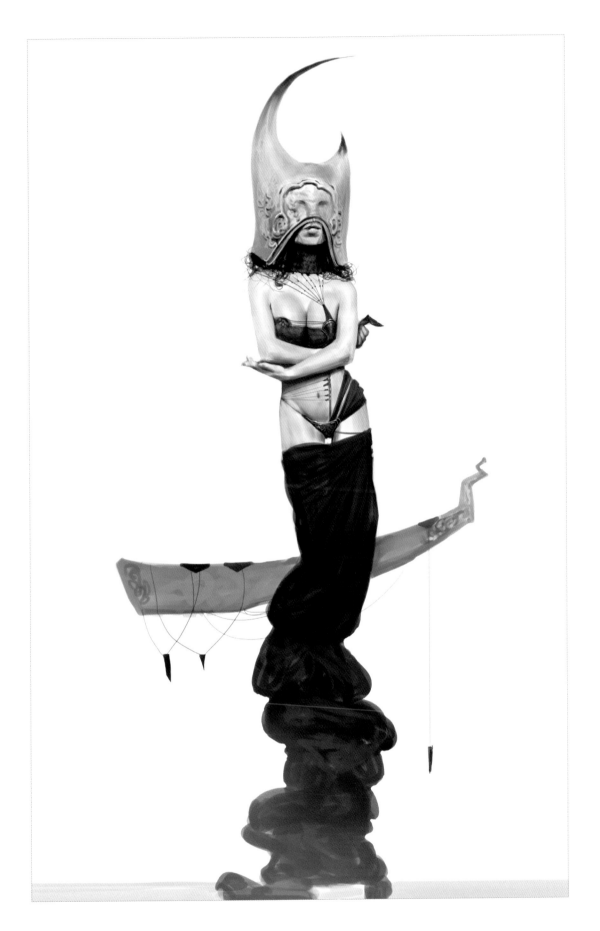

Jas

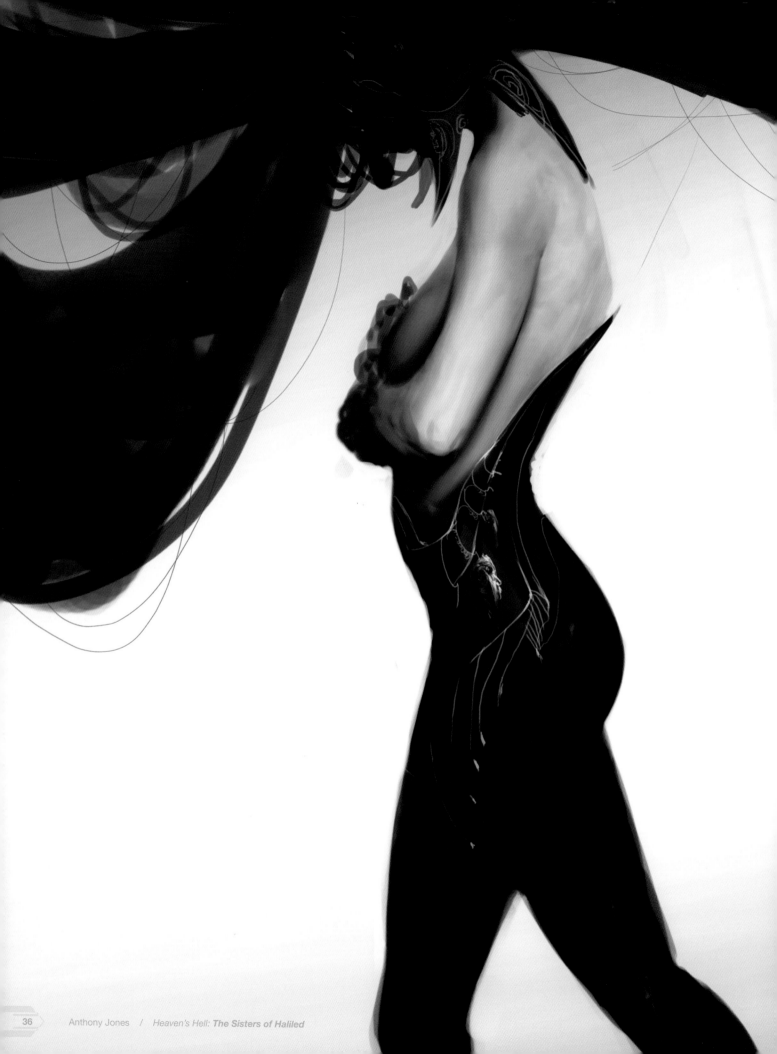

Jasis

Haliled's greatest warrior, Jasis, is also whom she yearns for. This, no one must know.

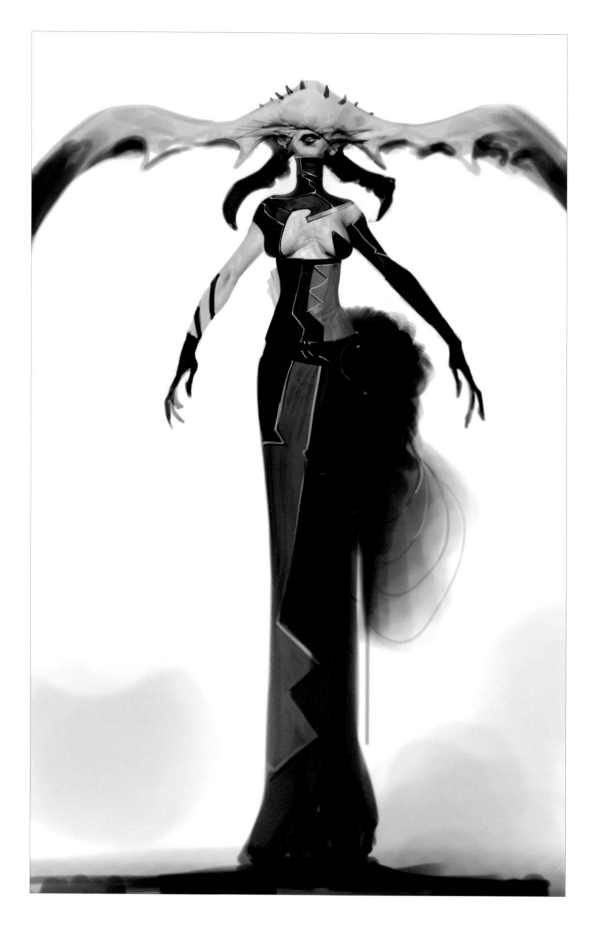

Passinia

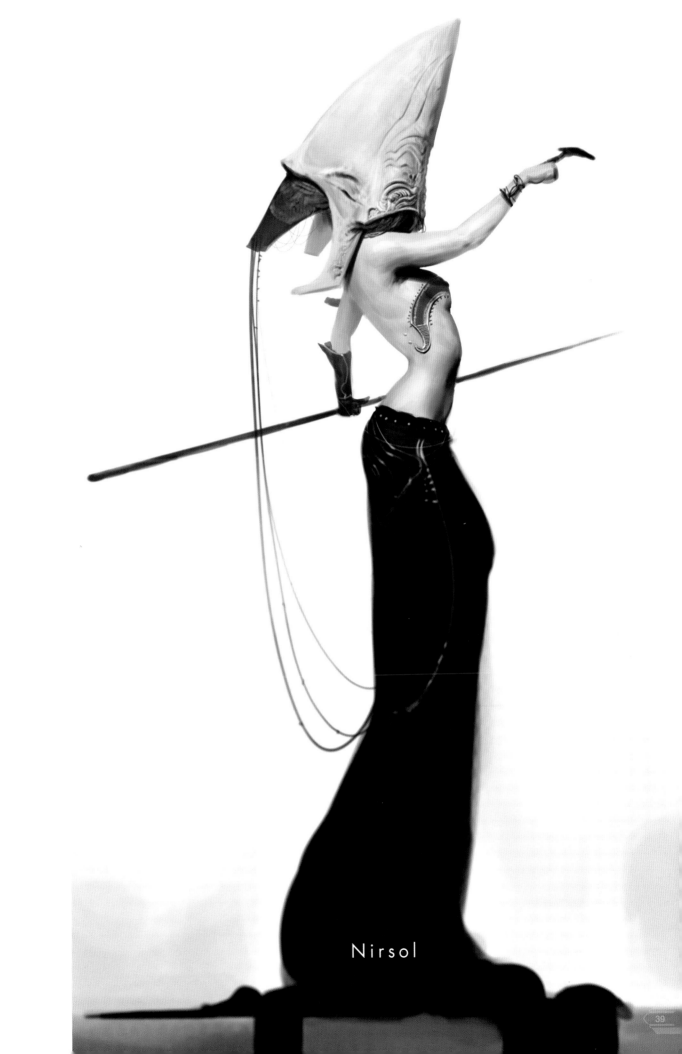

Nirsol

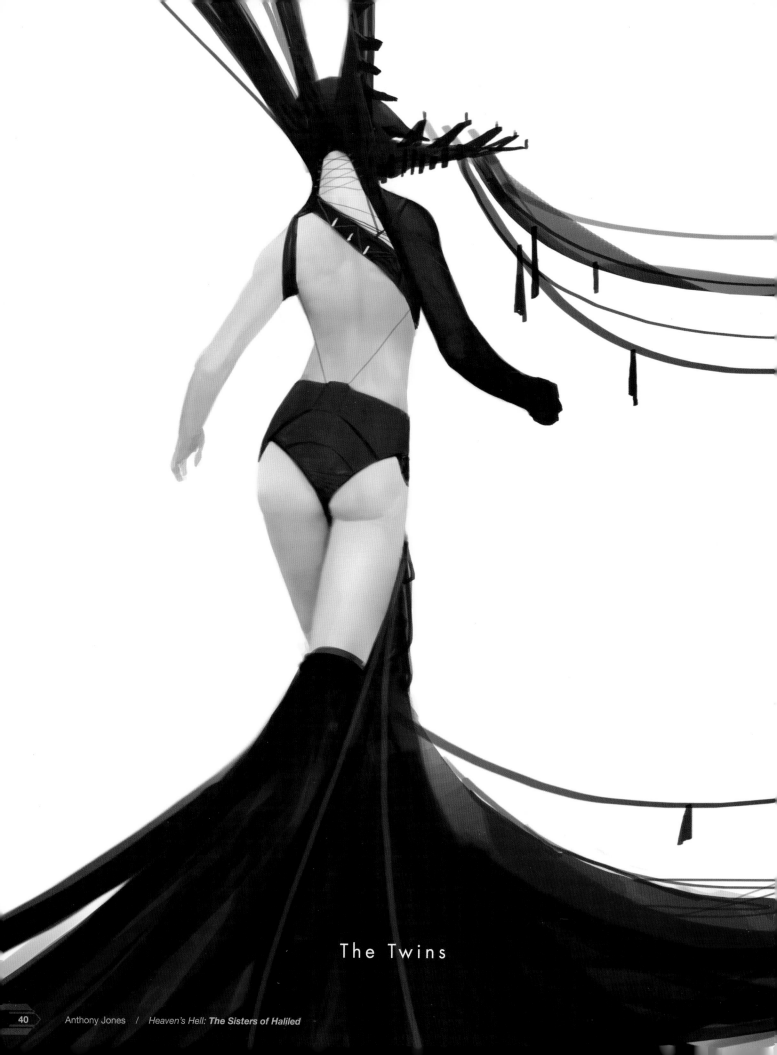

The Twins

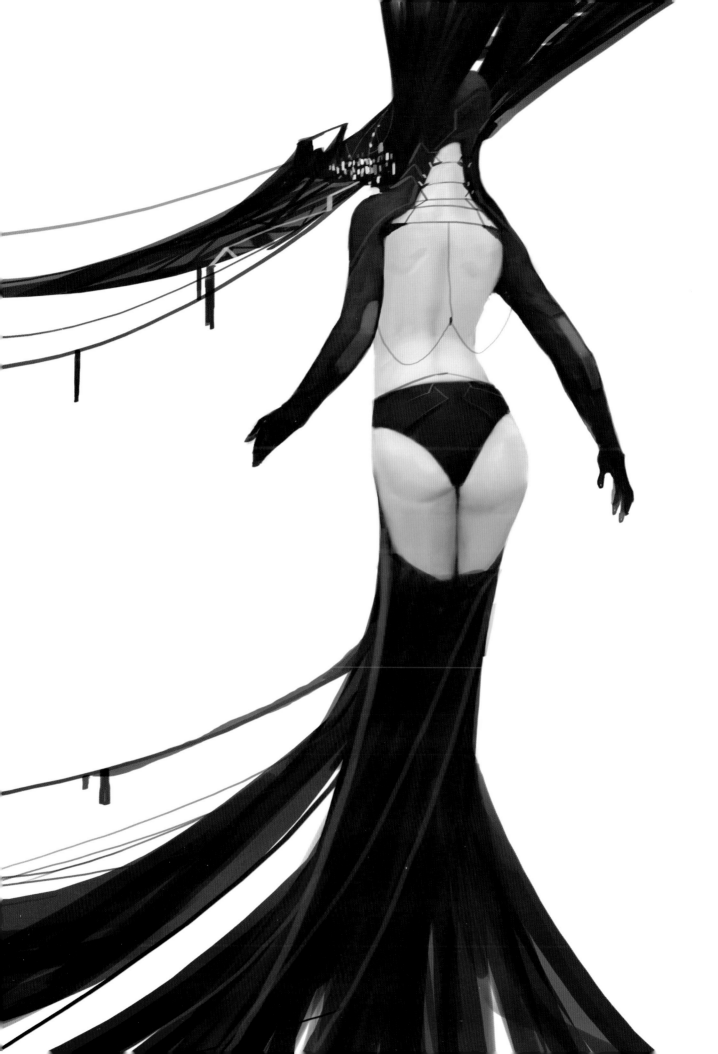

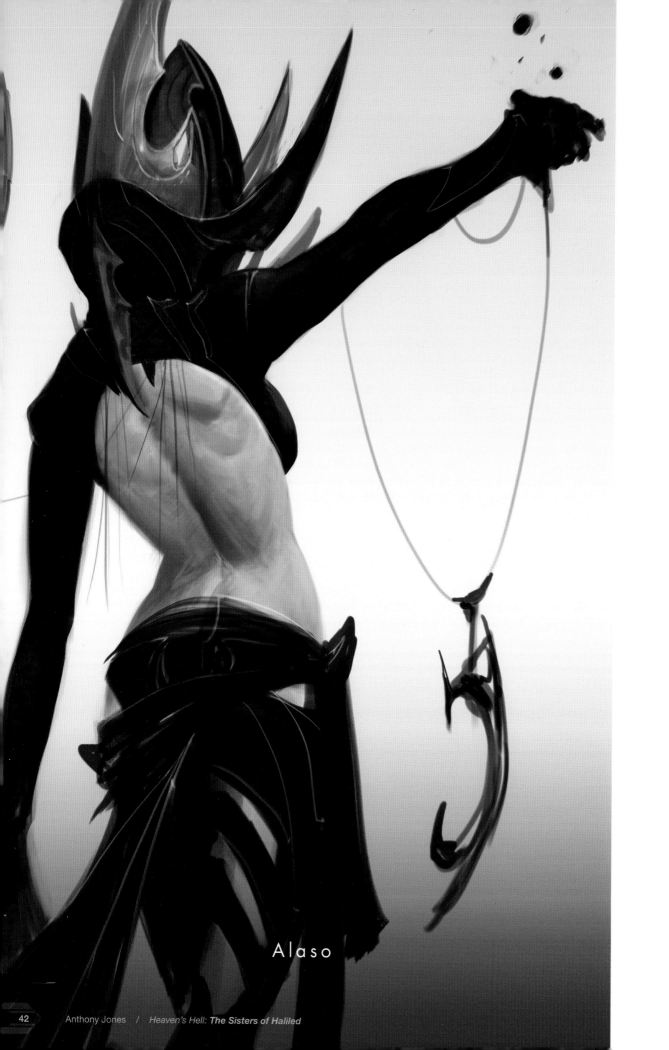

Alaso

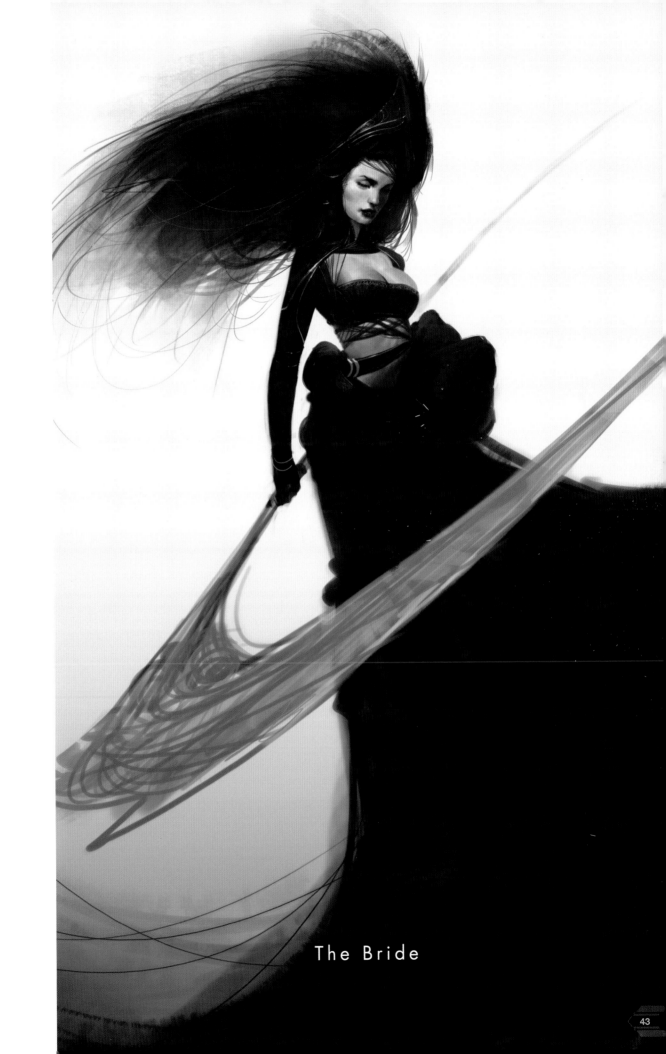

The Bride

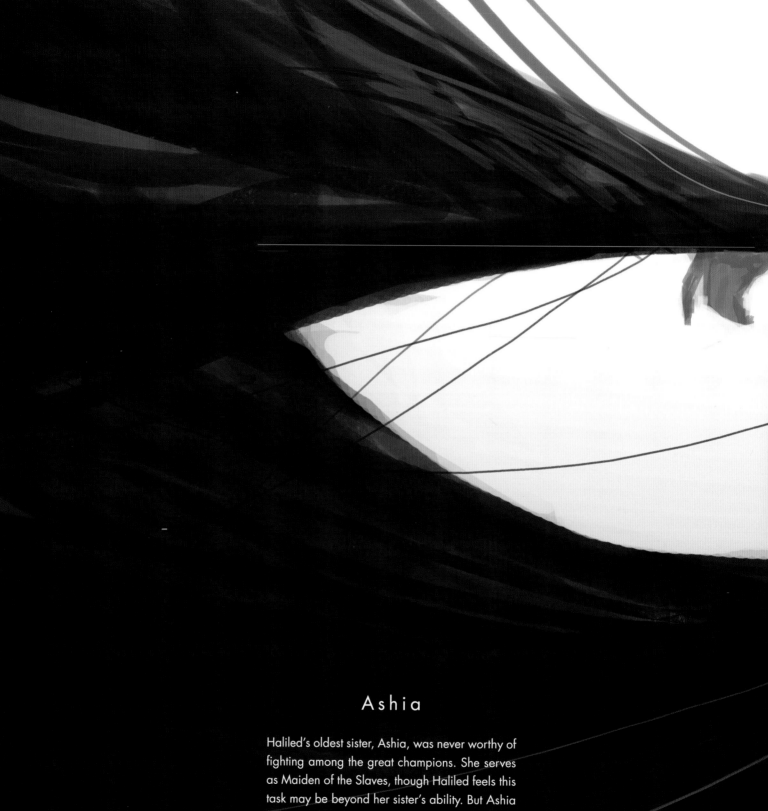

Ashia

Haliled's oldest sister, Ashia, was never worthy of
fighting among the great champions. She serves
as Maiden of the Slaves, though Haliled feels this
task may be beyond her sister's ability. But Ashia
is more gifted than she appears, as are the souls
she cares for.

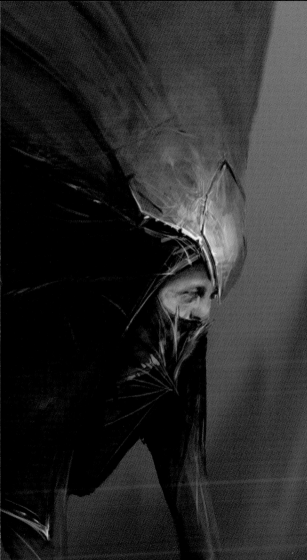

THE SAPPHIRE
SAGES

The Sapphire Sages are loyal to no one except the darkness. They believe
there is neither a beginning nor end, that nothing is truly what it seems,
and that there is more beyond the afterlife. Surrendering to madness is the
only path to freedom.

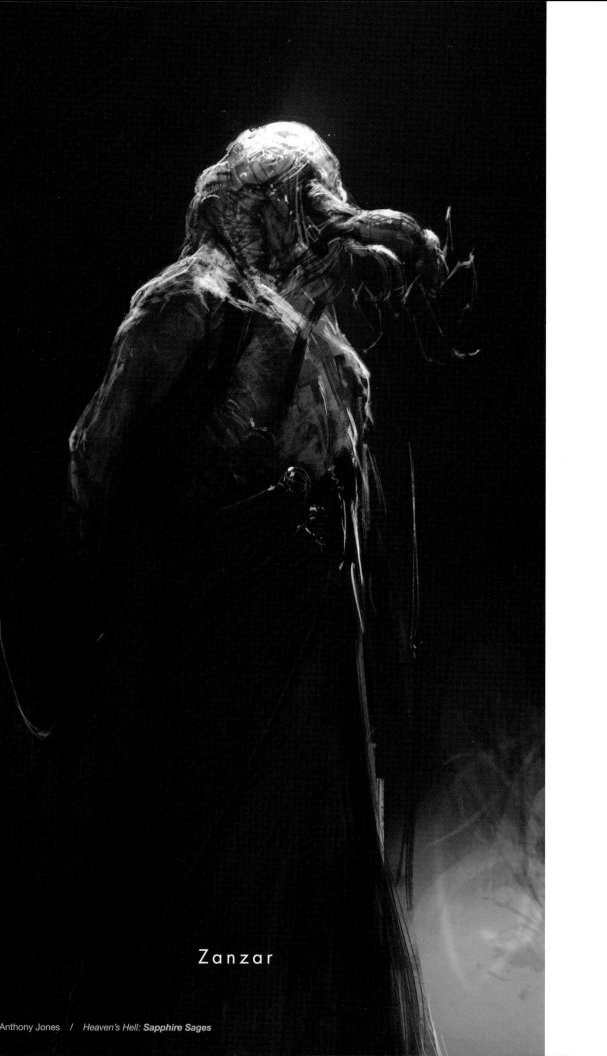

Zanzar

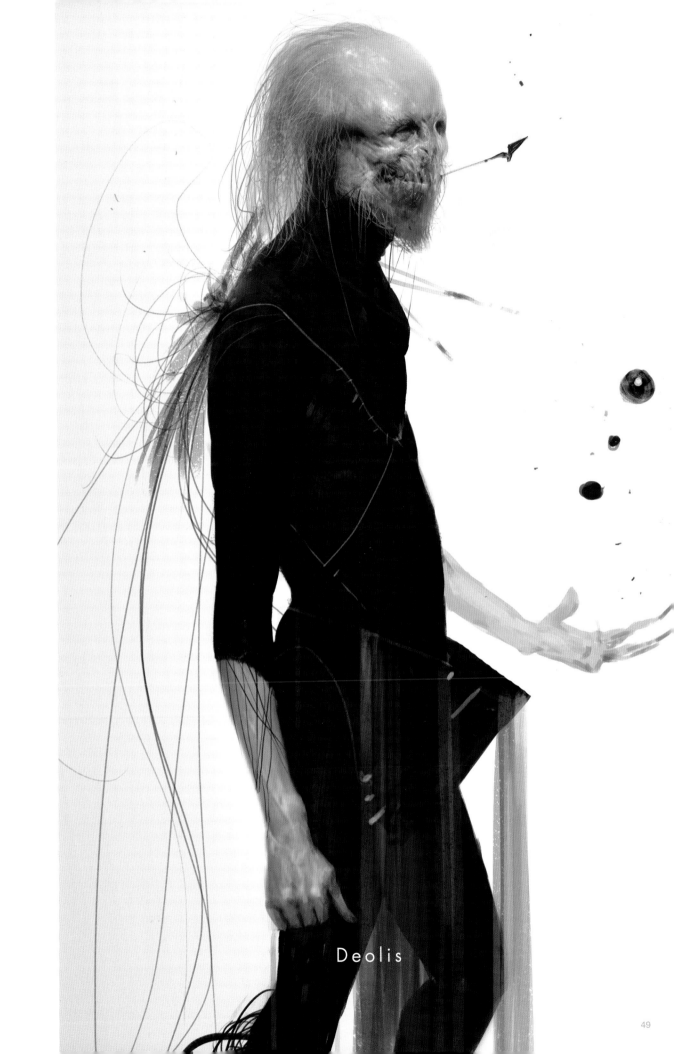

Deolis

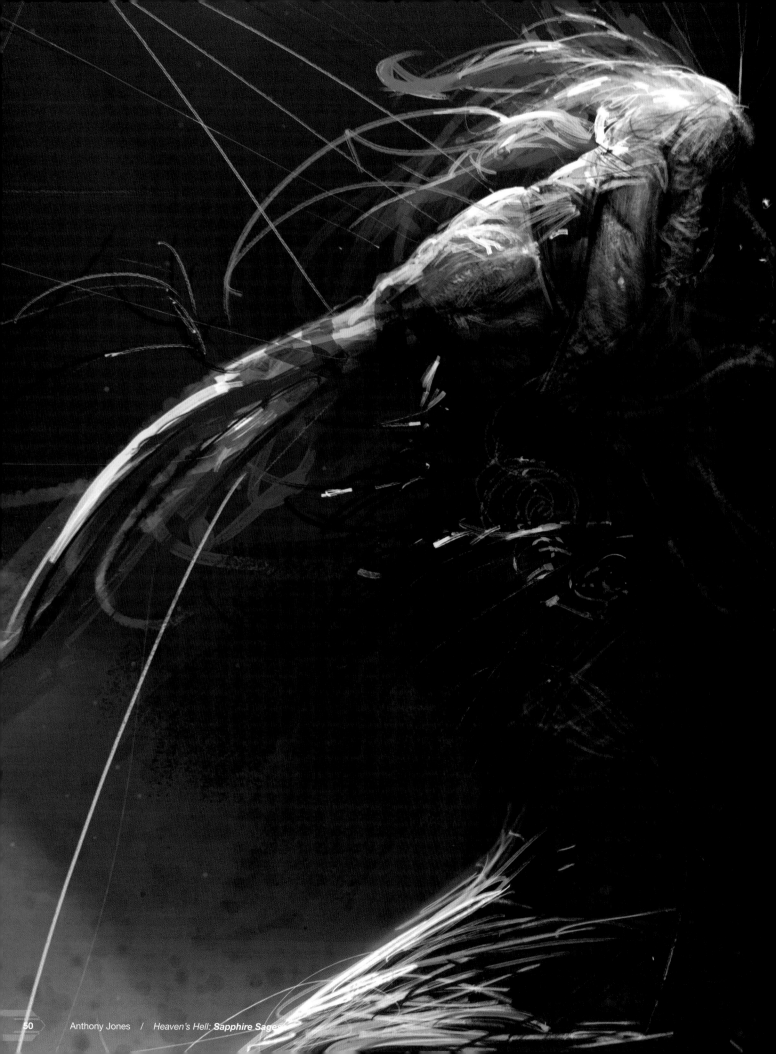

Ilozar

No one finds greater pleasure in tormenting minds
than Ilozar, whose face has yet to be seen. Those
who have encountered Ilozar have only been able
to say this of his—or her—appearance: "death that
comes from blinding light."

Eyes of Zanzar

Anthony Jones / *Heaven's Hell: Sapphire Sages*

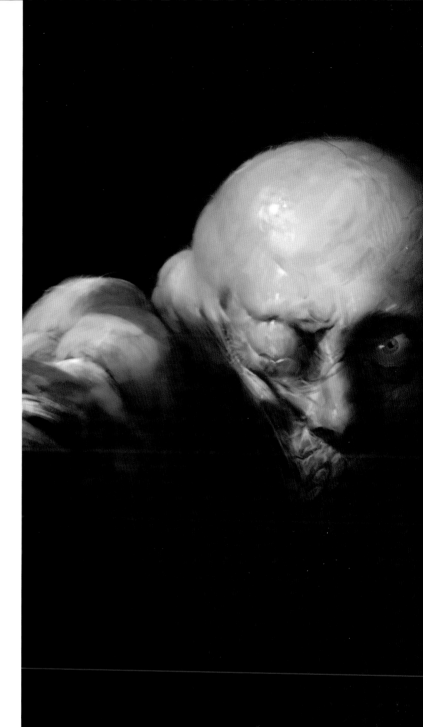

Marsolas

THE BROTHERS OF JISAIS

Courage is death's favored delight. It is your end. To be courageous is to be vulnerable.

Do not seek to die with honor, but rather to live forever.

Immortality is our right, and it is only fear that guards that right.

Trust in fear, for that is where your true power lies. It prevents death's wish of our demise. To live in fear, is to continue to live.

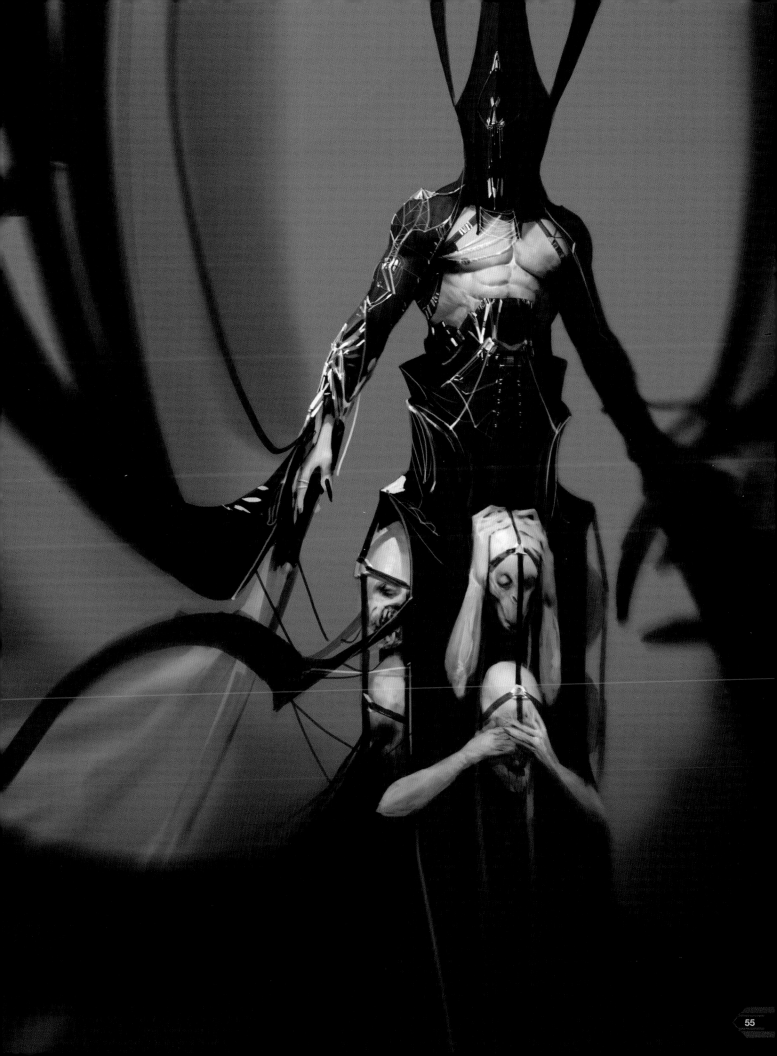

There is no greater coward than Jisais, yet it is his fear that strengthens him. It is his key to survival. Though do not follow his tactics because they are foul and dishonorable. Many noble men have died by his hands.

In this world, the courageous seem to perish while Jisais lives on. Bravery makes the Brothers of Jisais laugh because there is no one without fear, and to deny this puts their adversaries at a disadvantage.

When you step onto the battlefield, it is how great your fear of death is that will lead to your preservation.

FIGHT FOR LIFE, NOT FOR HONOR.

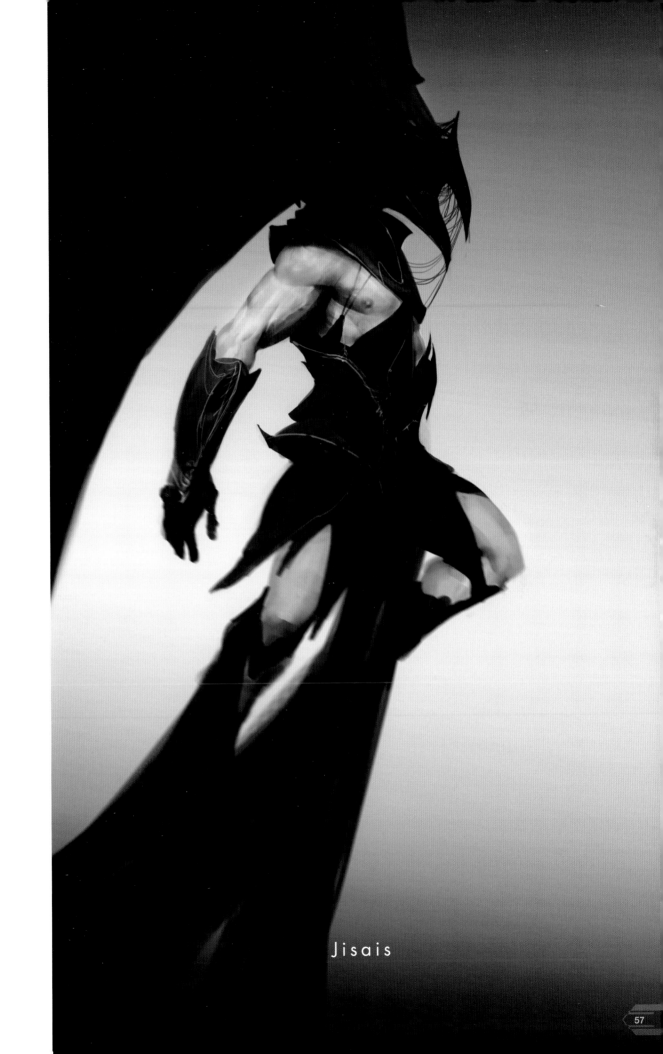

Jisais

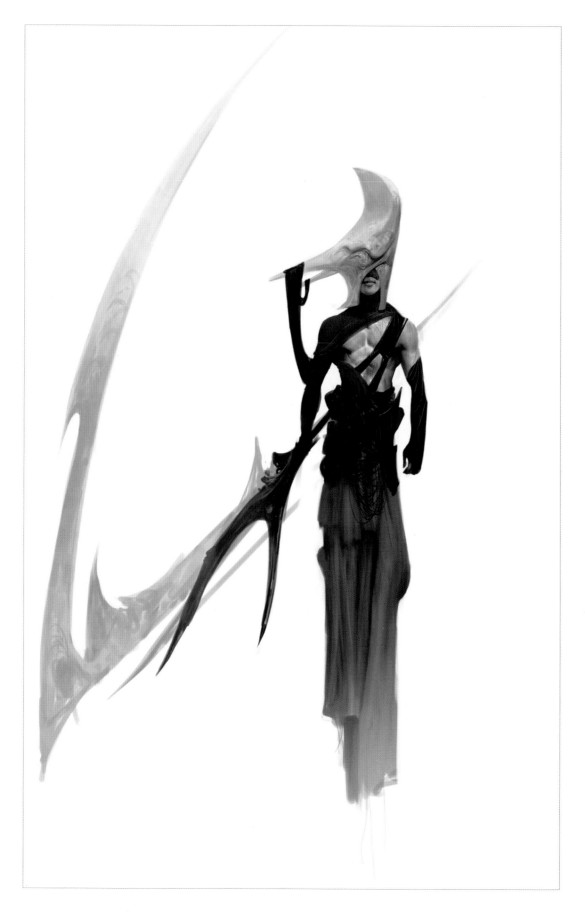

Salris

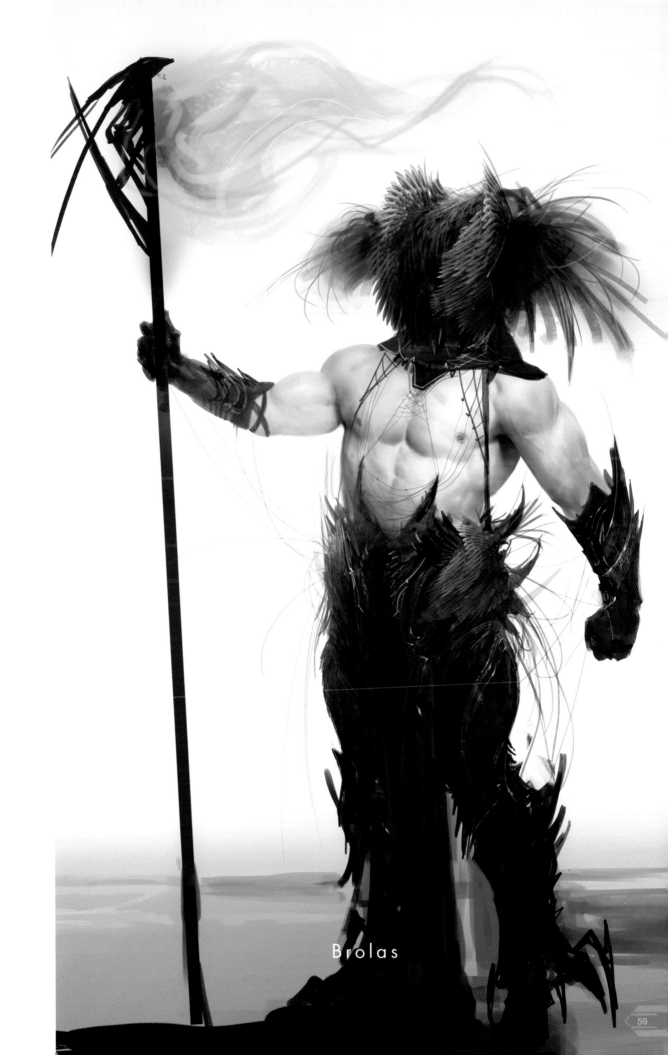

Brolas

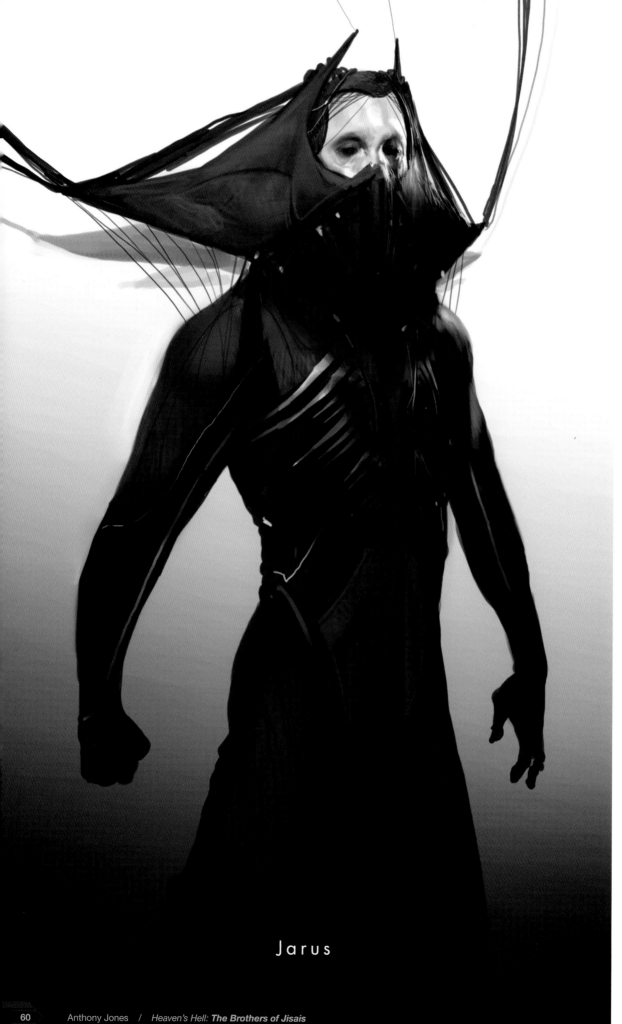

Jarus

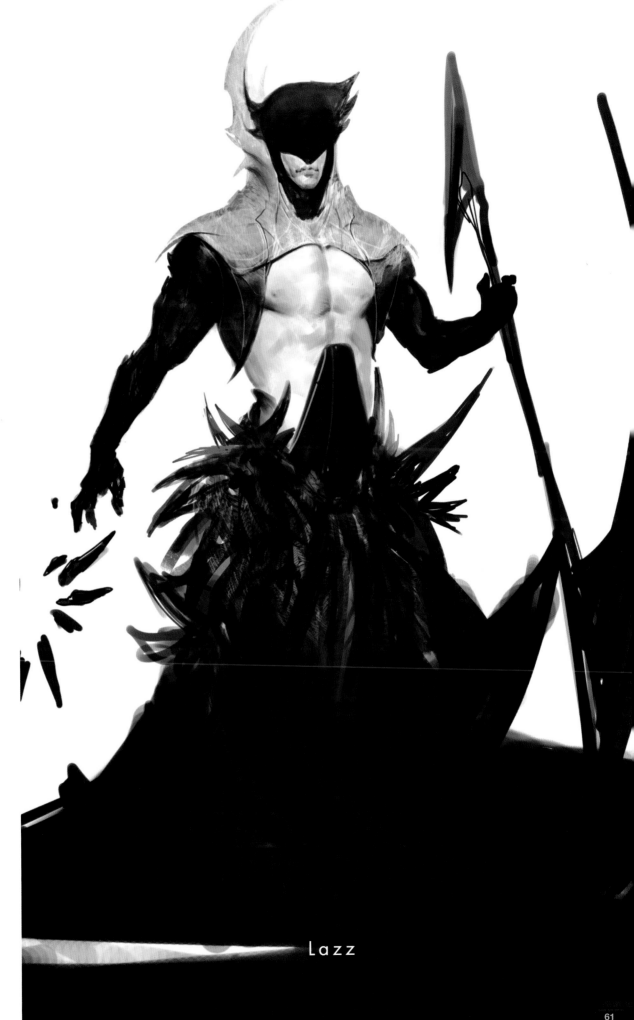

Lazz

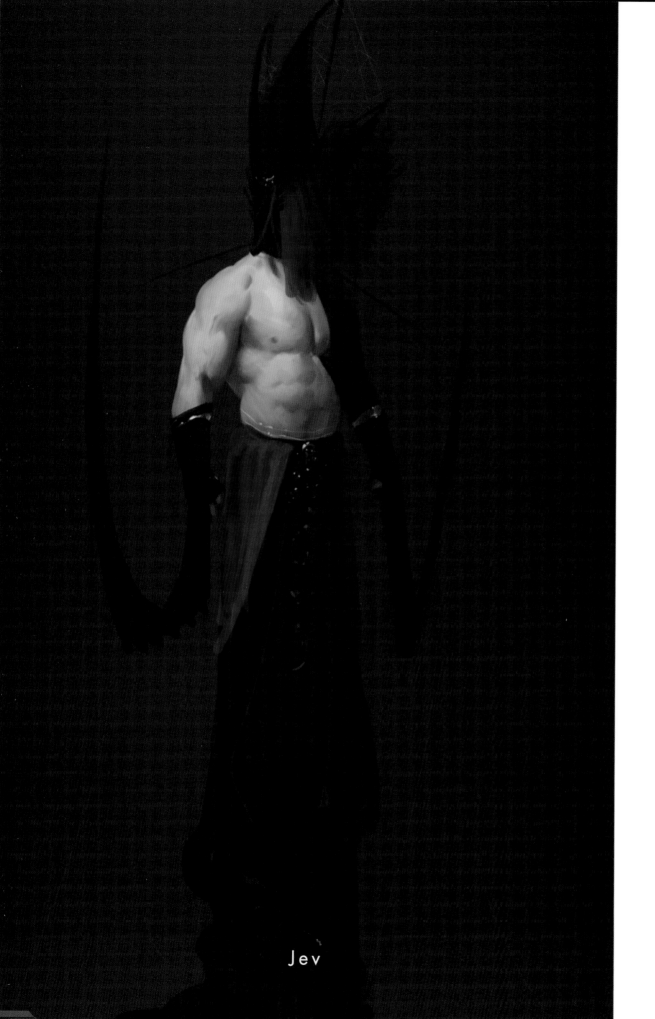

Jev

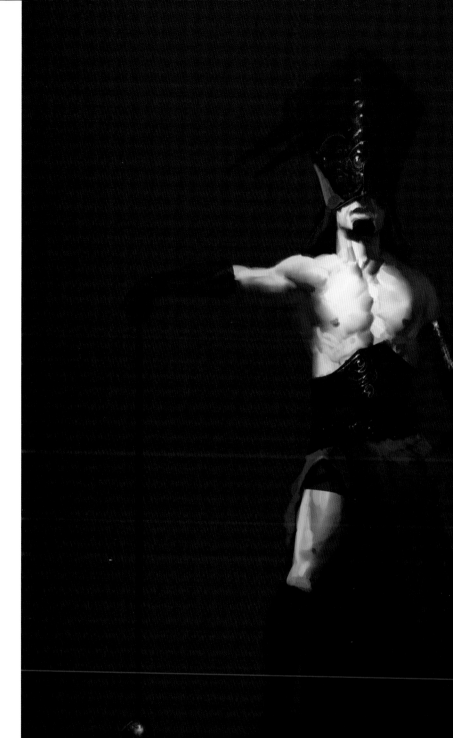

Stev

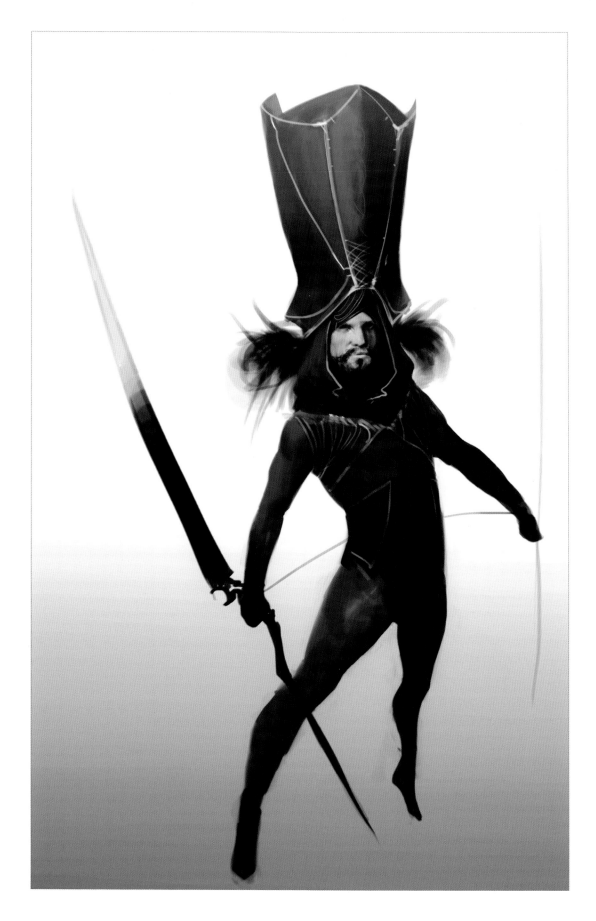

Lazalon

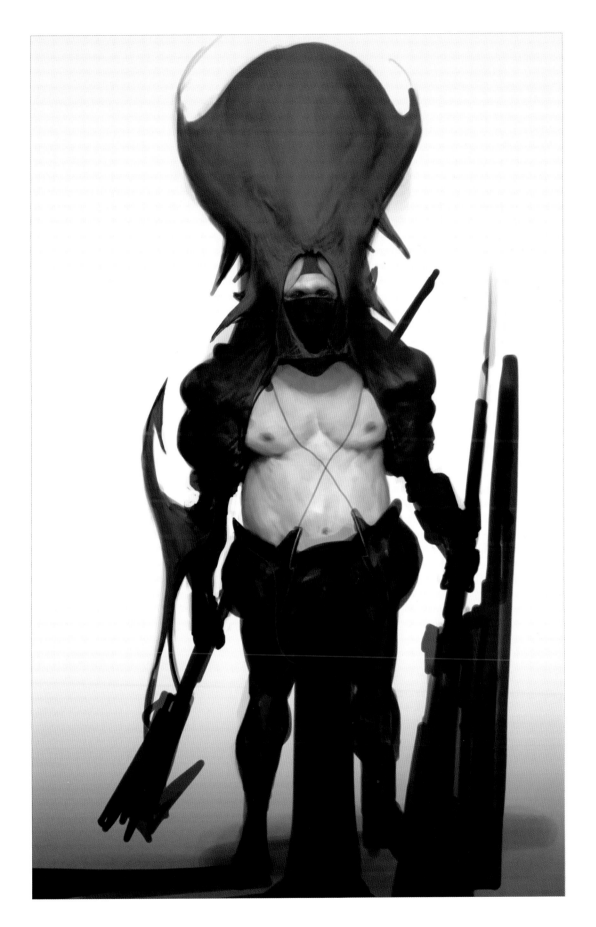

Devast

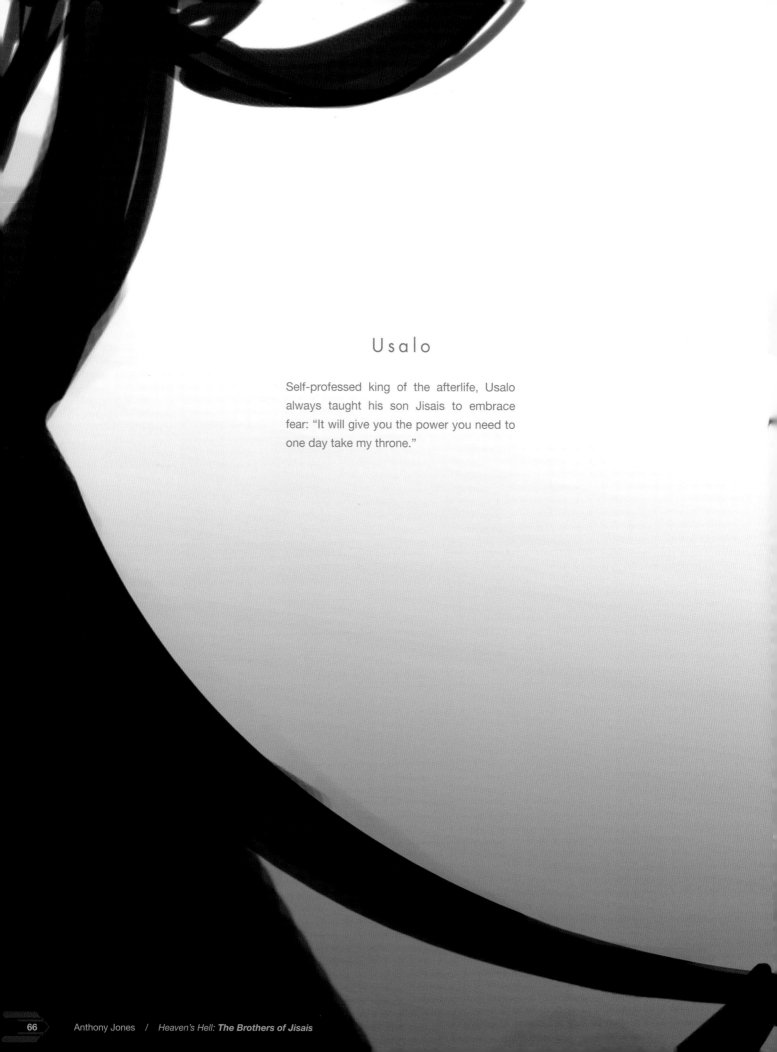

Usalo

Self-professed king of the afterlife, Usalo always taught his son Jisais to embrace fear: "It will give you the power you need to one day take my throne."

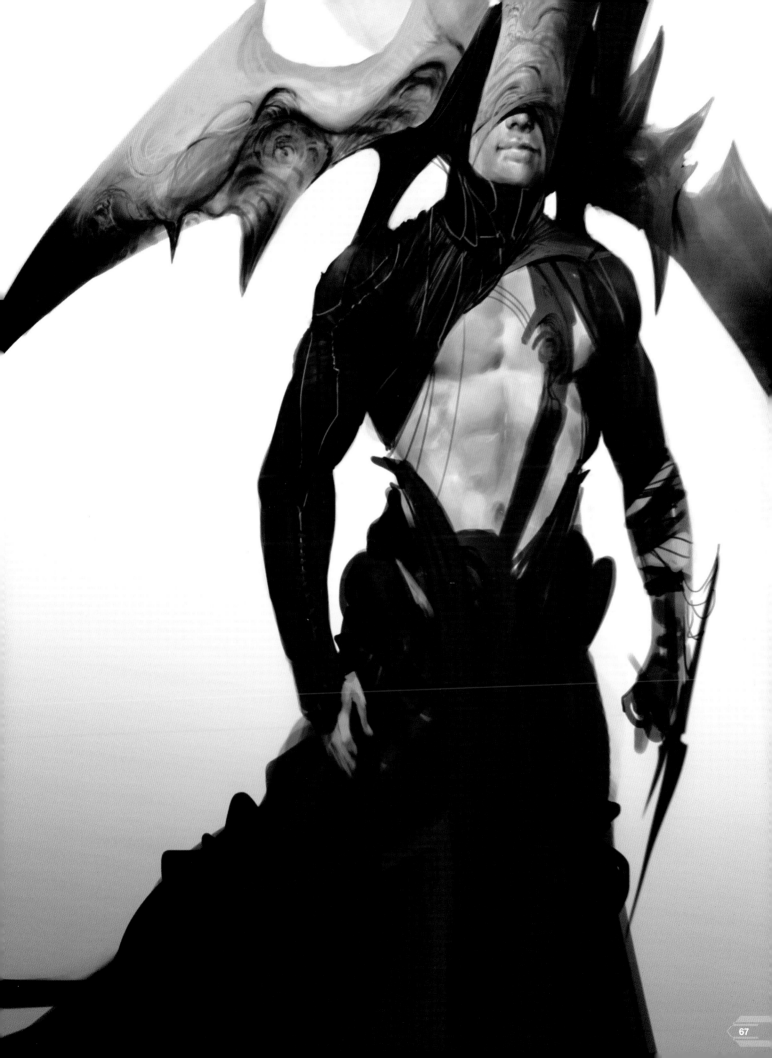

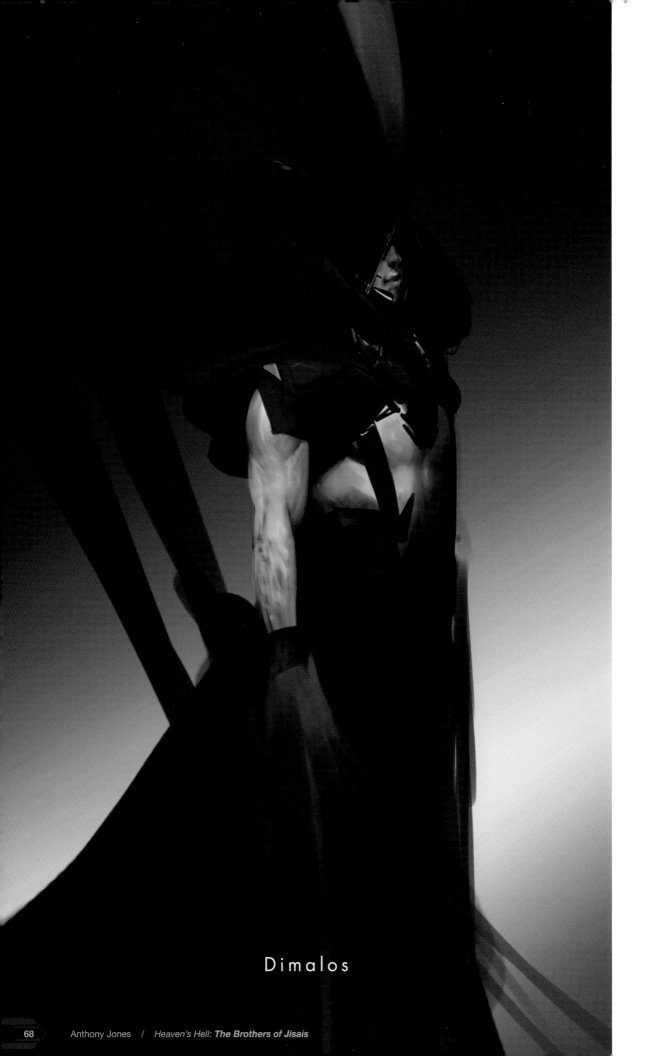

Dimalos

Anthony Jones / *Heaven's Hell: **The Brothers of Jisais***

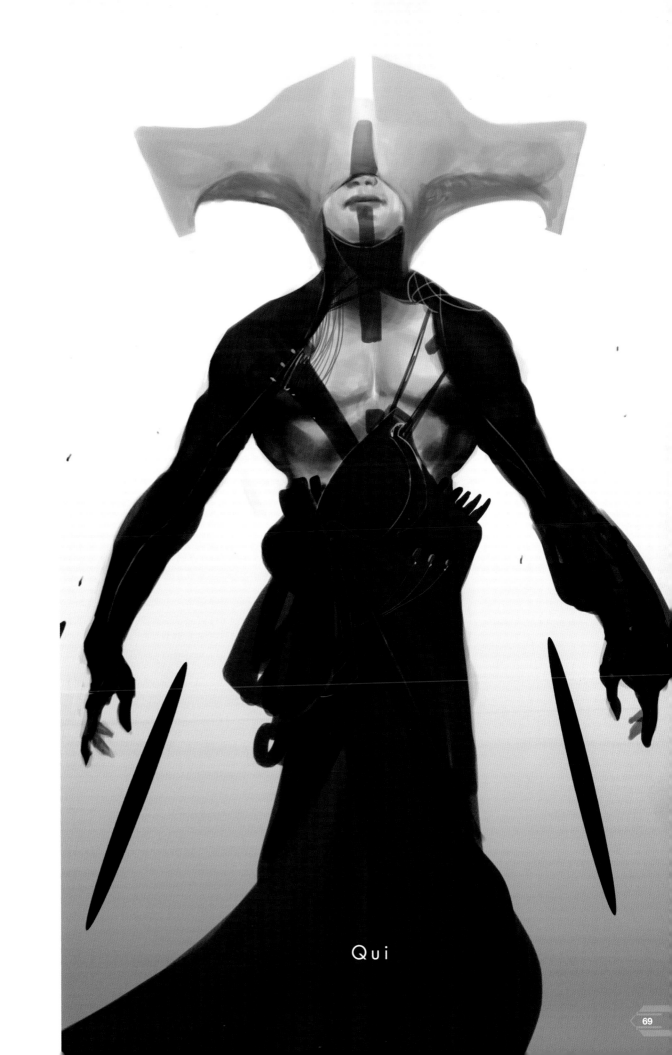

Qui

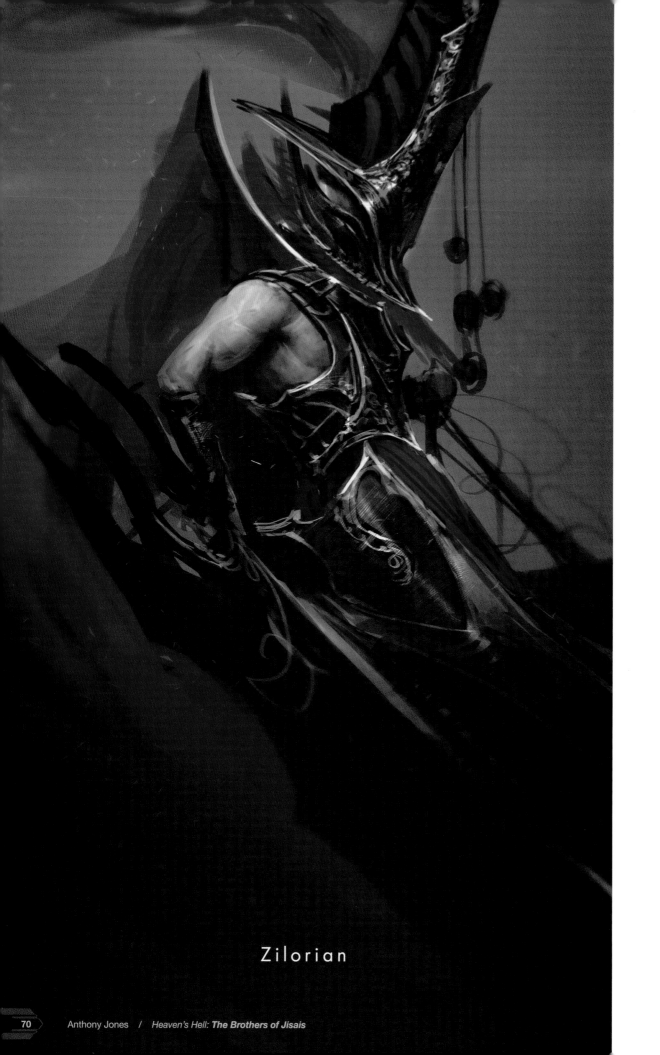

Zilorian

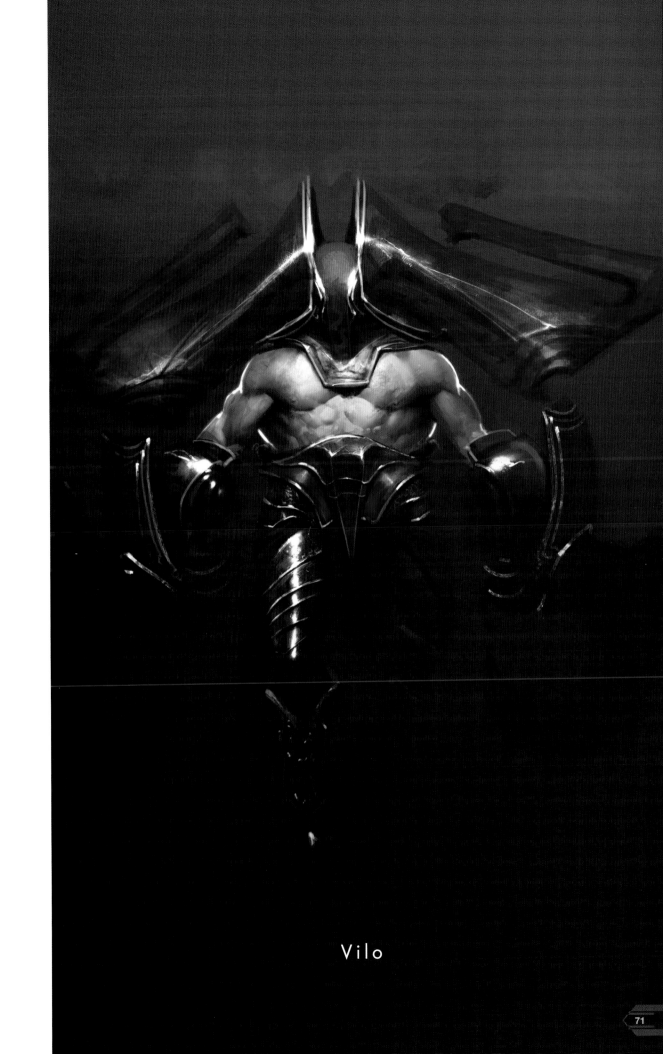

Vilo

Anthony Jones / *Heaven's Hell: **The Brothers of Jisais***

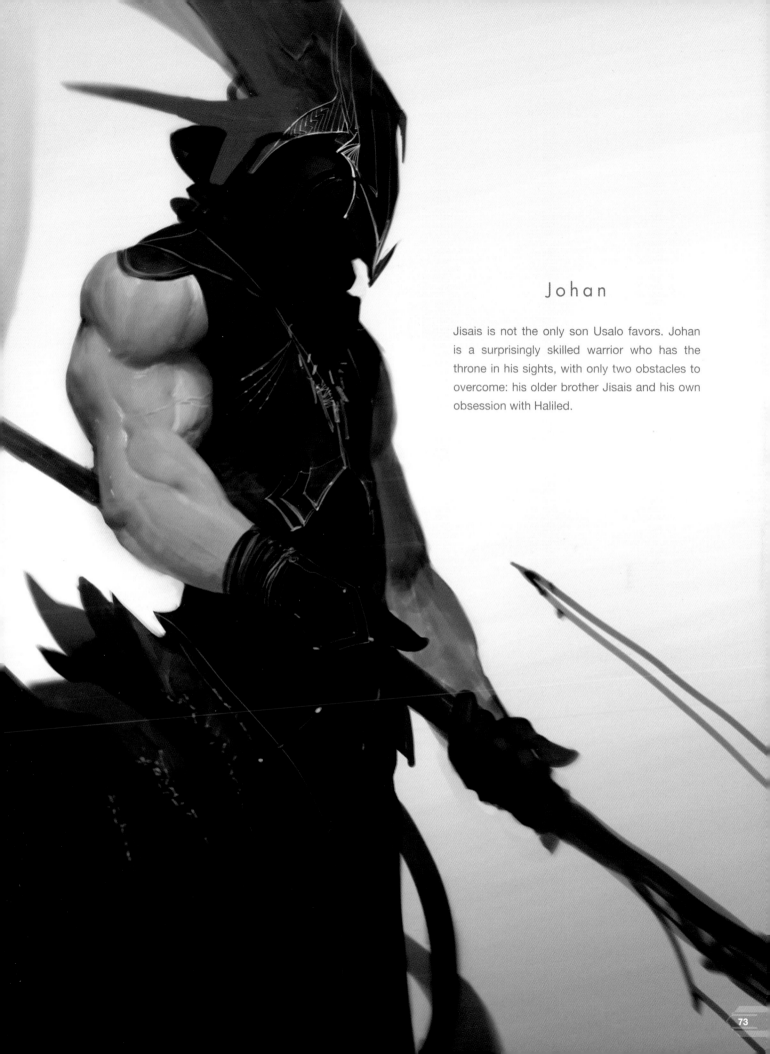

Johan

Jisais is not the only son Usalo favors. Johan is a surprisingly skilled warrior who has the throne in his sights, with only two obstacles to overcome: his older brother Jisais and his own obsession with Haliled.

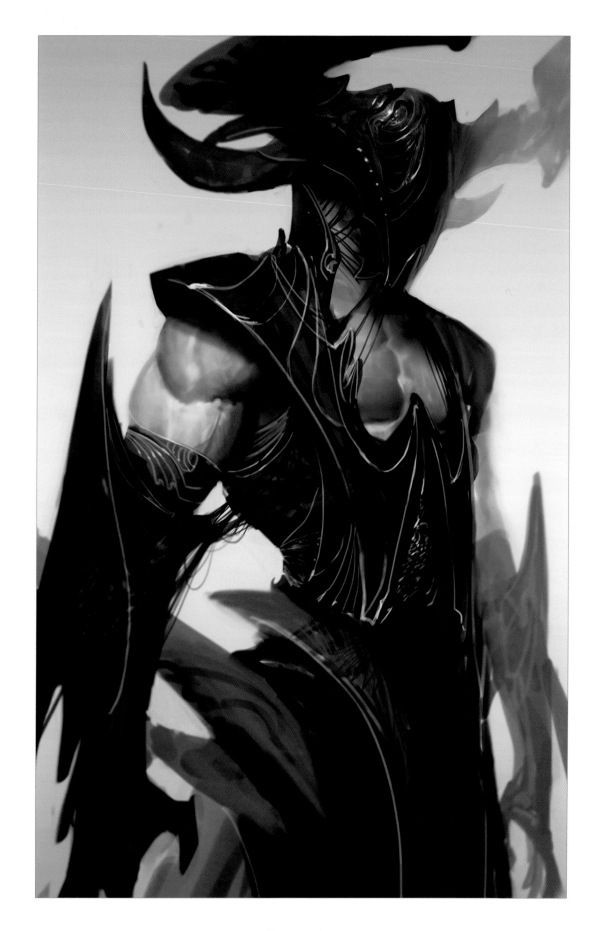

Fasula

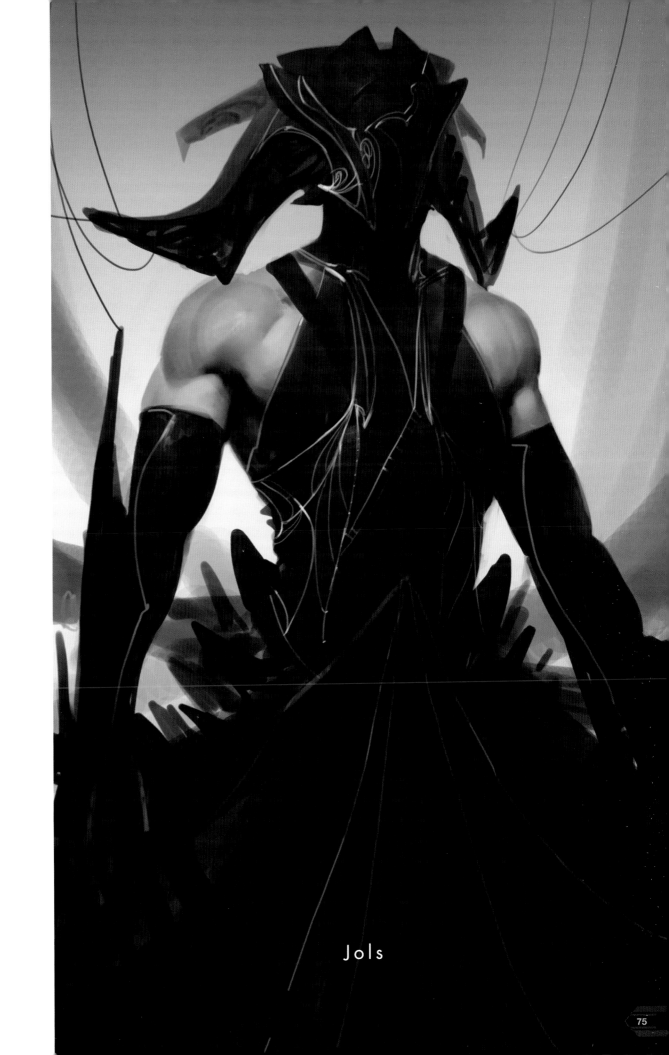

Jols

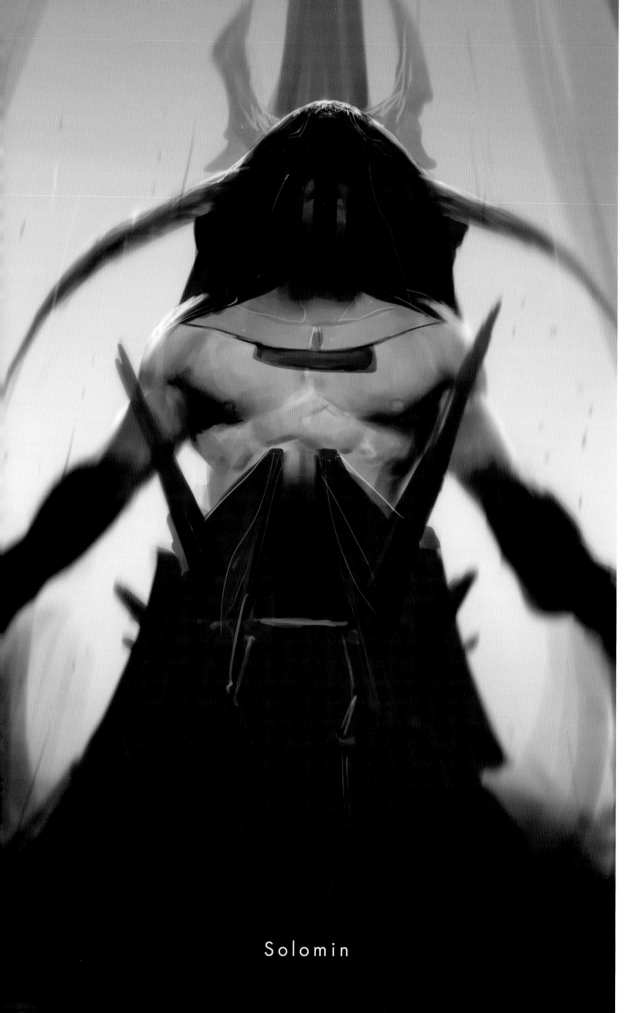

Solomin

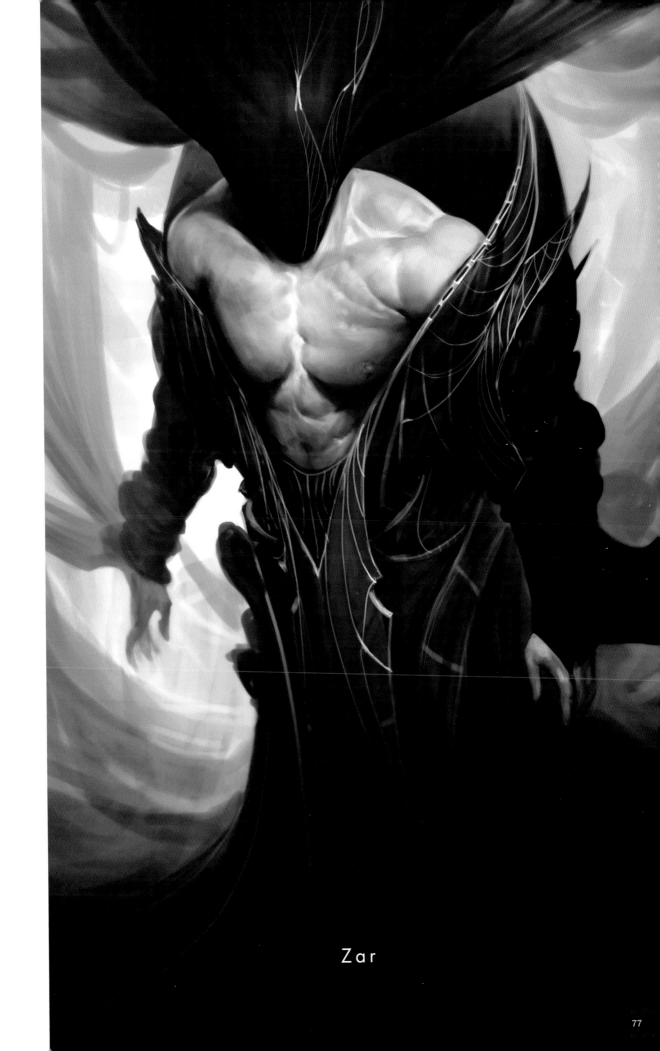

Zar

CHARACTER
TUTORIALS

Designing characters from your imagination is not easy, and it requires one crucial thing: studying. By this I mean you need to study various pieces of information. I believe that developing your own style, something that has tremendous visual aesthetic and weight, requires you to be truly educated.

You see, art is a skill and creativity is a skill. These are things you can acquire versus talents you are born with. You aren't born creative, just like we aren't born walking. The more you walk the better you become at it. Eventually, it becomes so natural that you don't even have to think about walking. Unfortunately, in terms of creativity, there is this skewed belief that you either have it or you don't. This, to me, is absurd.

When we were children, we all drew at the same level. It's just that some kept at it while others didn't. You may think that it's easy for me to say this because I'm an artist, but the reality is that I became an artist at the age of 23. Before that I worked at the Gap, and I was also a plumber's assistant. I even started art school as a programmer. I earned the title of artist, and this is what I'm trying to teach you. I earned my creativity and my sense of design, and here is how I did it: lots of studying.

I looked at many styles of art and exposed myself to many design aesthetics. And I studied them all. I overanalyzed all information, I questioned it, and I always searched for evidence and facts. To produce good art, I apply factual information about good aesthetic design and anatomical structure, and utilize a practical understanding of the properties of light. People like the art that I do, and it's no accident.

With all this in mind, the guides and instruction on the following pages will give you some insight into how I created the characters for *Heaven's Hell*—work that was only achieved by a tremendous amount of effort.

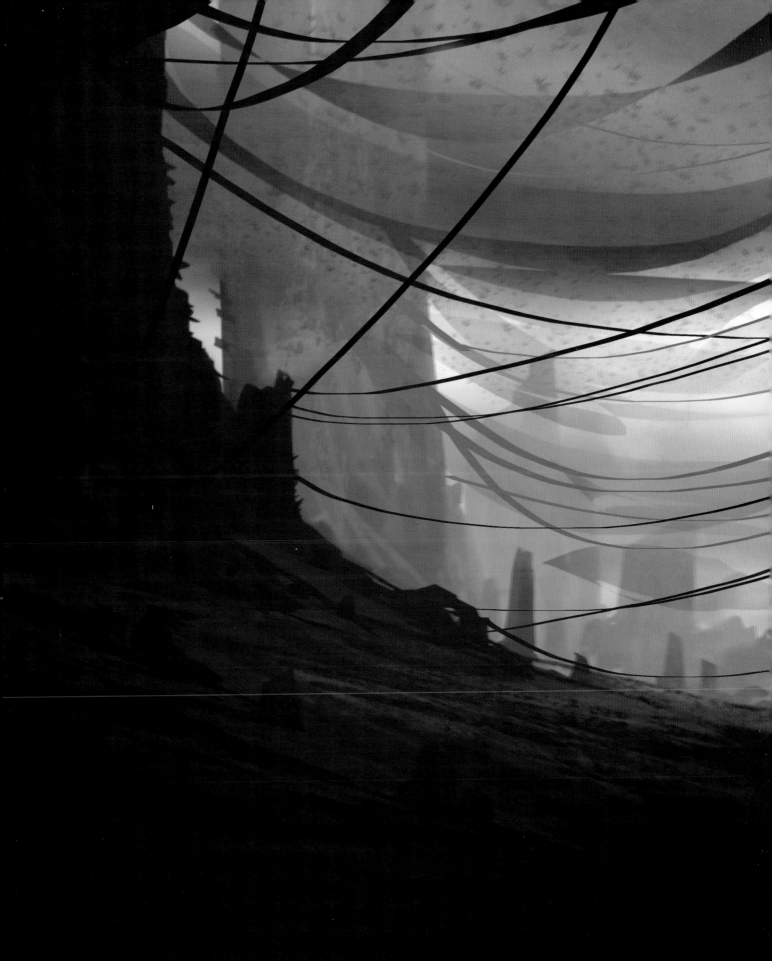

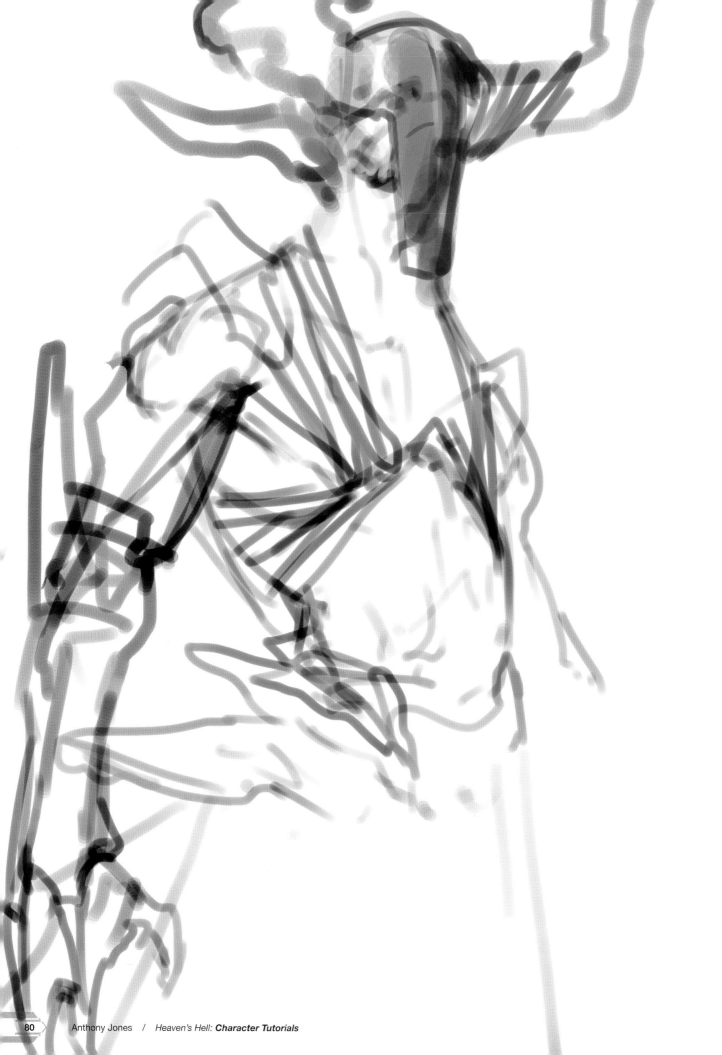

For Fasula, I used a simple round brush (A) to start sketching basic proportions and anatomy, laid in basic armor shapes, and hinted at potential value "breakups."

(A) Standard Brush

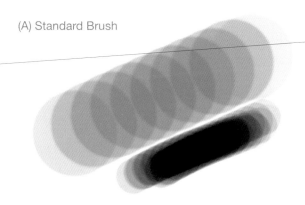

Next, I laid in values and solidified the shapes of everything. It is important to note that when I did this I did not lift my Wacom pen for each segment. The reason I do this is so that I can keep the shapes at the value I want.

There are instances of overlap, which is fine, but the goal is that the values that overlap create natural contrast. I kept a note of this in my next step. This helped me save time and work later. "Noodling" only adds more time to how long it takes to finish the piece, so it's important to always be making decisions, instead of guessing.

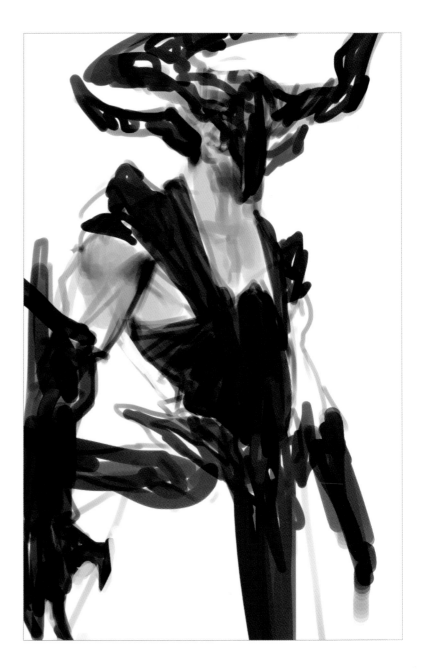

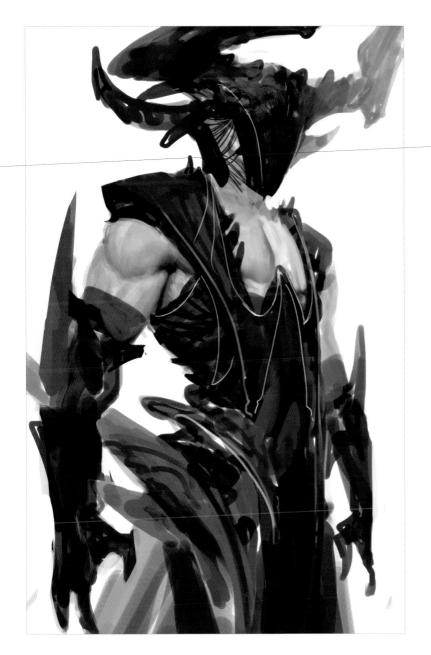

The next step in this painting was to find depth and form in my shapes. I did anatomy checks and usually kept some decent reference around for the occasion. I continued with a lot of controlled scribbles and crosshatching that would help initiate detail in the next step.

Remember the contrast overlap that I was talking about in the previous drawing? I decided to change the values and have it go behind the arm instead of in front of it. I also added secondary values everywhere to inform what was in the foreground. The primary value breakups are still there.

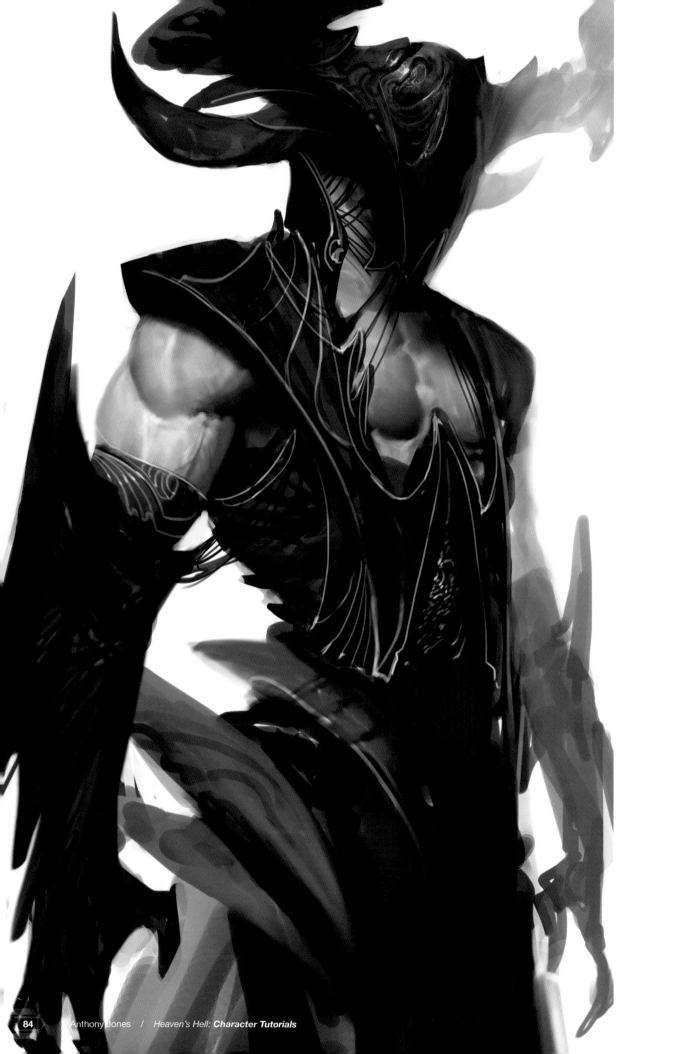

Here I go nuts with detailing, but I typically use a smudge tool (B) to refine this step. It helps blend the hard edges together, and collects the noise in the same way. I also use a soft version of the basic brush, which can be adjusted in the brush presets under hardness.

 (B) Smudge Brush

Before After

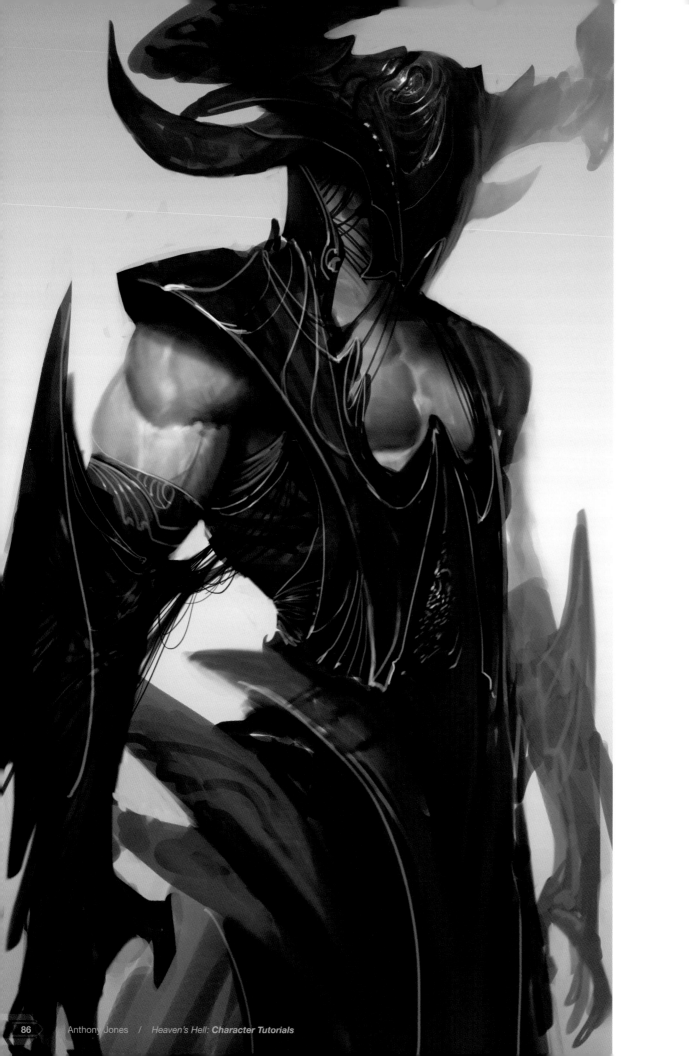

This painting is now almost final as it is getting to the point where I'm happy with it. To finish the image, the process I used was manipulating curves (see Curves window below) to get the sense of color and tone.

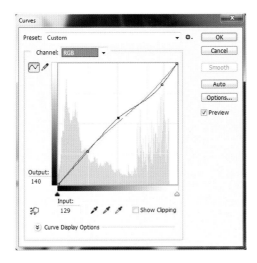

The next step is to use Chromatic Aberration, which can be found in Photoshop CC, in order to create the illusion of taking a picture. Normally if you take a picture with a normal lens there is a little afterglow of cyan and magenta on the border of your subject; this is an imperfection of a camera that I fake to bring more realism to my painting.

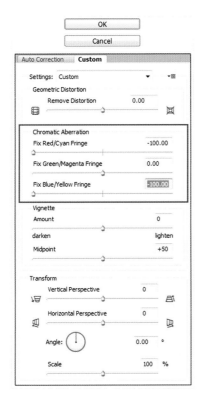

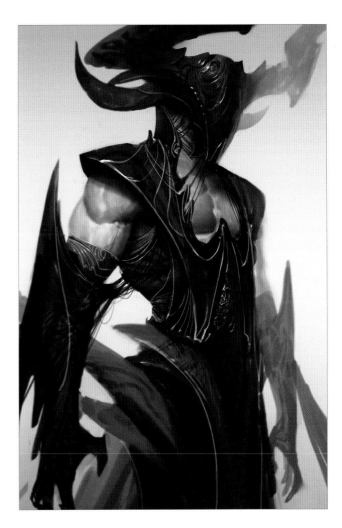

Above is the final image. Now you can see the result is not as mysterious as it was when I first started this character.

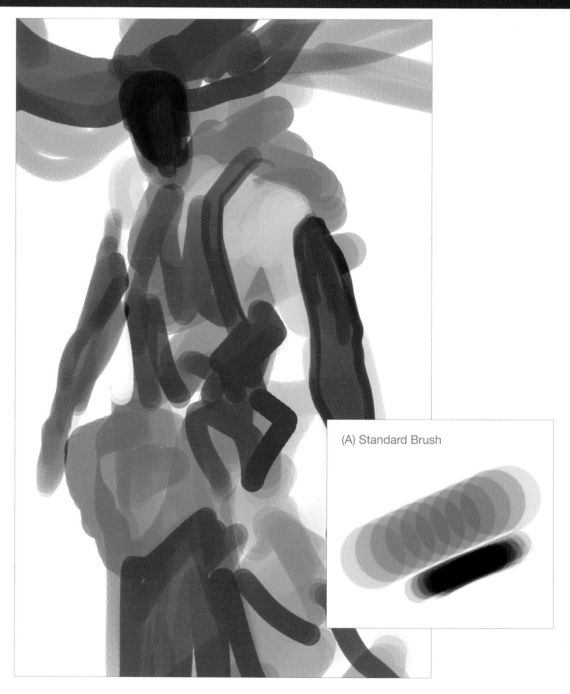

(A) Standard Brush

With Zar, my technique was to start with more shapes versus lines, as I did with Fasula. This is typically how I go about my paintings, but sometimes it's good to have a sense of form by establishing it through lines. No approach is wrong if it gets you to where you need to go.

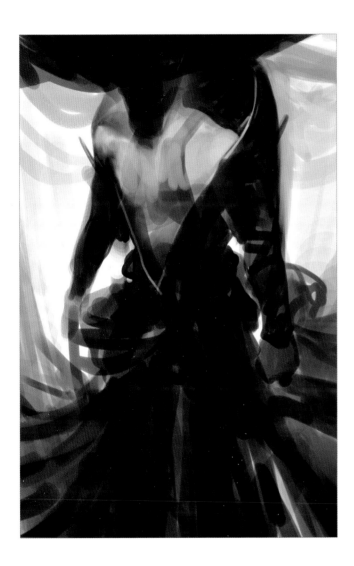

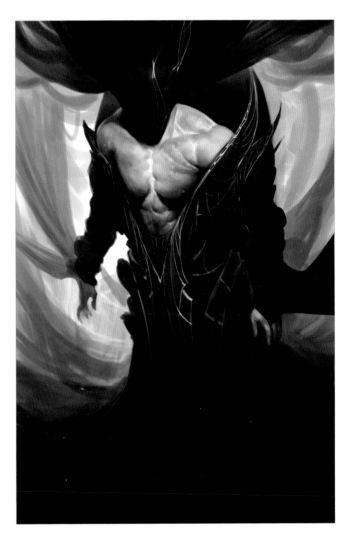

This image shows the massing at a more precise level. To help my edges remain sharp, I try not to lift my Wacom pen often. I should note that as I do this process I change my brushstroke dramatically and frequently. This helps me establish scale within the design and also allows me to approach macro/micro shapes often.

Obviously the last step is detail, which you see here. I just take all the ideas from the rough block in and try to iterate on the forms with detail. Details such as trims and crosshatching are a great way to reinform the shapes and ideas that I have for the outfit.

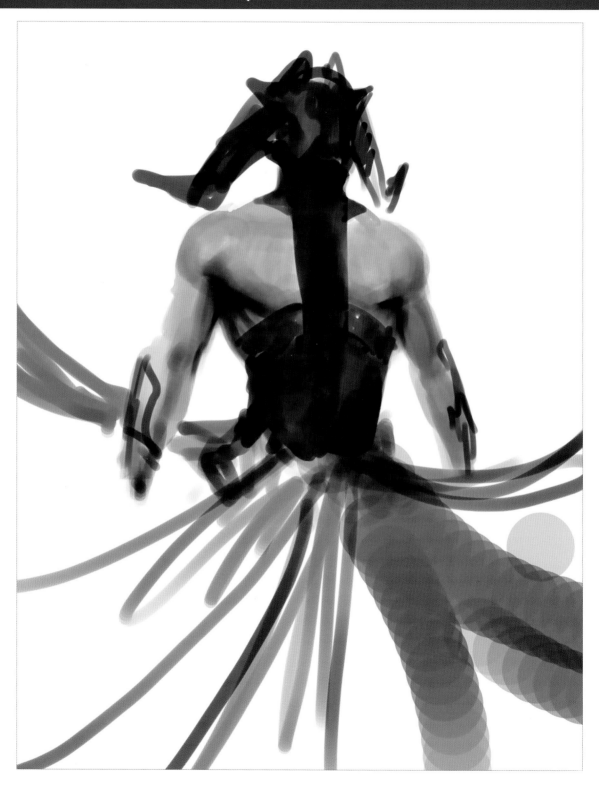

With Jols, you will see I used some of the same techniques as in the previous tutorials. The images in this spread are blocked in using the standard round brush and by thinking of value and line at the same time.

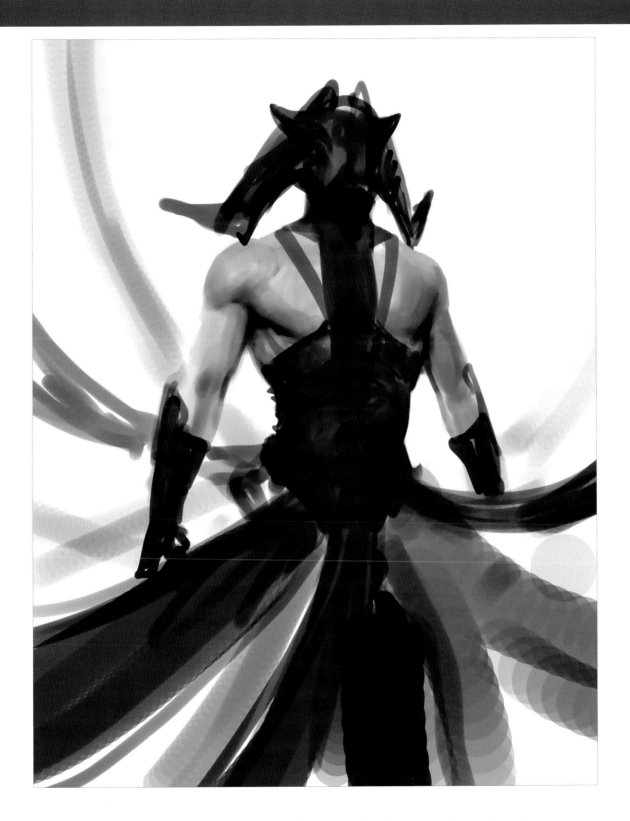

Here I wanted to achieve a bit more overlap with his costume. Overlap is a great way of establishing a sense of depth in an outfit even though it is one solid color. The light and dark contrast benefits from this type of method because it can allow your design to appear simple and complex at the same time.

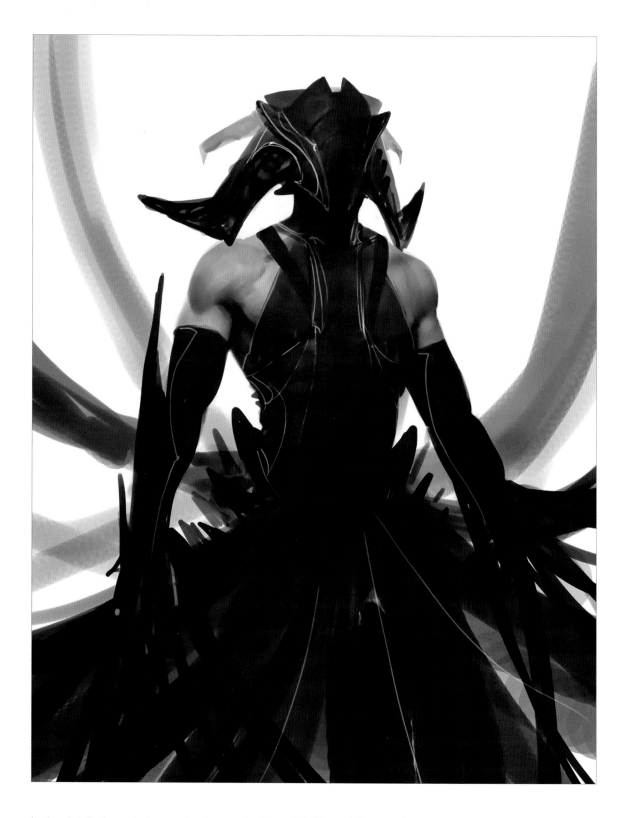

In the detail phase, I also made changes to the outfit. Since Jols started to appear extremely symmetrical, it was important to break that apart with some asymmetry within his trims and cuts. I loved using the trims and cuts as a way to establish more focus to elements like the helmet. I even changed up the trim on the chest and abdomen areas to echo that idea further.

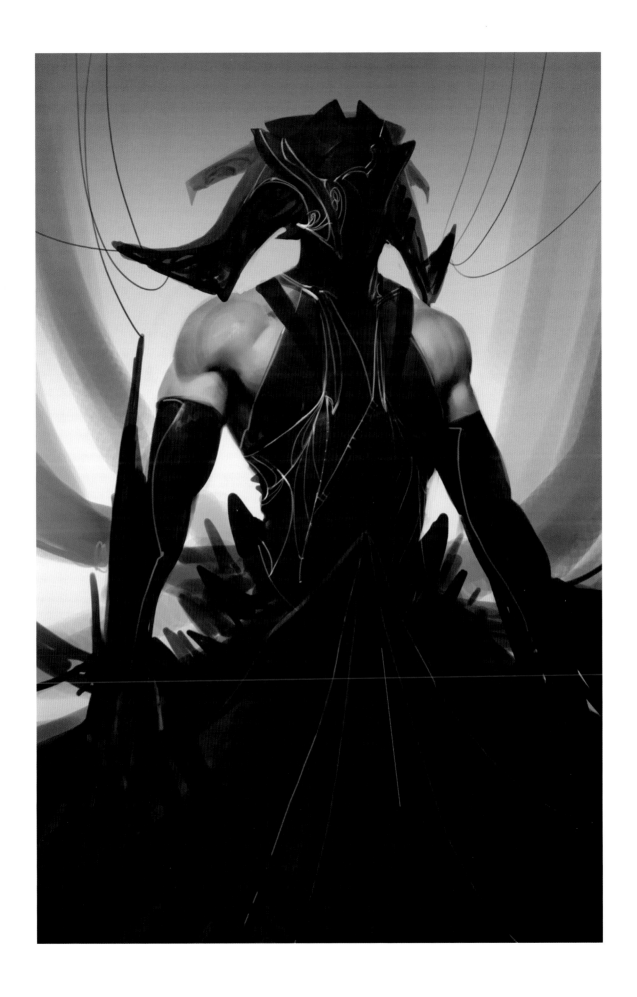

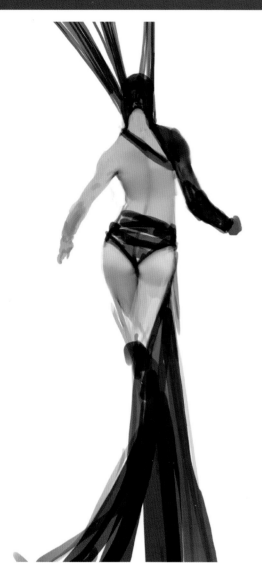
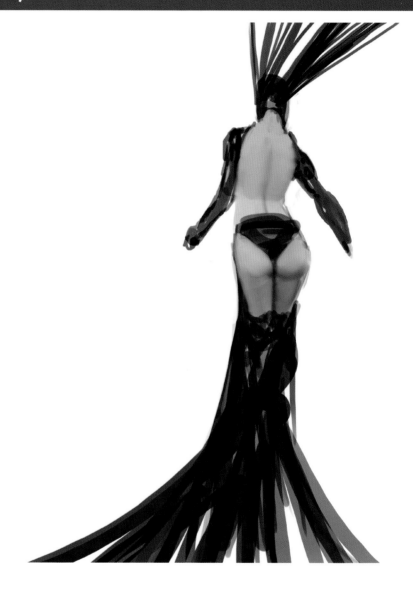

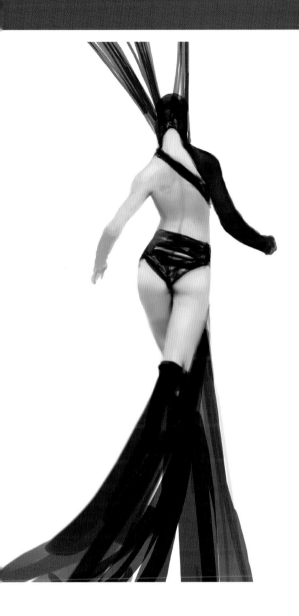

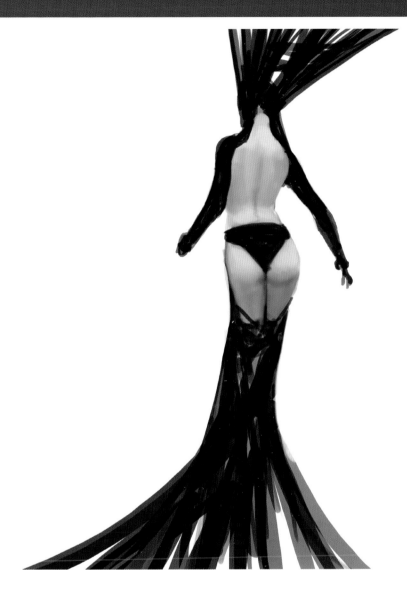

With the Twins, I started with a value breakdown and then defined the elements that will be found in the painting. I tried to hit an 80 percent rate of finish, allowing for 20 percent of touch-up details, such as design adjustments and the addition of color.

Trust me that this actually takes the longest out of all the processes, because it is the foundation of the whole illustration. I feel that a painting can be solved in the first 10 to 15 minutes of it being started. After that, it is a matter of just reworking or fixing mistakes to your design that should have never been there from the beginning.

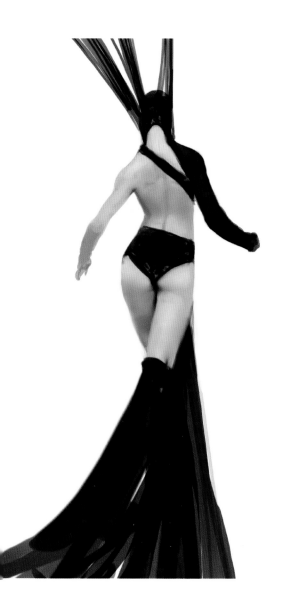
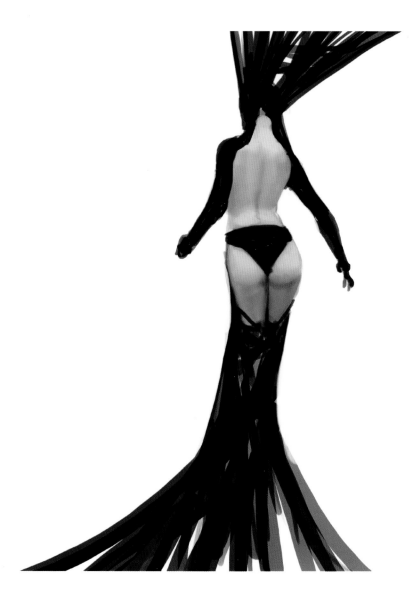

This phase is when I started to apply color. This process is actually quite simple. All I did in Photoshop was apply a color balance feature and mess with the "warms." I also made very specific selections to my values so that I could affect them individually.

One of the benefits of blocking your values very efficiently at the beginning is that selections can be made quite easily with the use of the Color Balance window in Photoshop. I also applied an overlay layer and painted using a red hue to pop out the shades of red more and make them a bit more saturated.

People are considerably baffled at the idea of adding color to value when they first start out, but as you become experienced, you will soon discover, like many other painters, that value is king; and it is the salvation to all your form/lighting problems. Color is just the frosting to the beautifully baked cake.

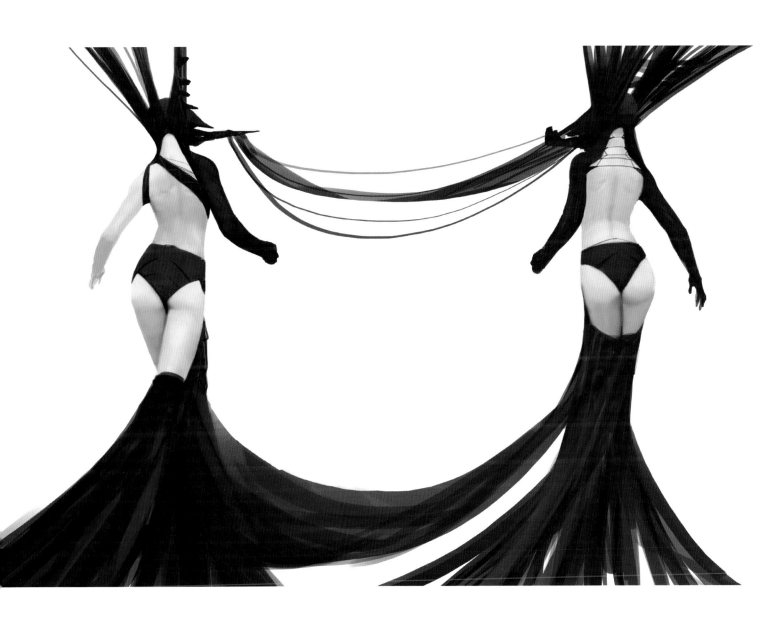

These are the final touches to my painting. I spent a lot of time just refining the edges, adding more detail, and adjusting the color by hand. I use this process often for production-type work, but this is especially powerful for my own personal work because I can push and pull the colors how I like. I can saturate them depending on what I feel is best for the illustration.

Adding more details once the colors are satisfactory can be very boring, so I try to not spend too much time just detailing. I just take it to where the viewer can clearly see the idea behind the painting, and leave a little room for mystery and discovery. The human mind is very great at filling in the blanks, so I leave the rest of the work up to you.

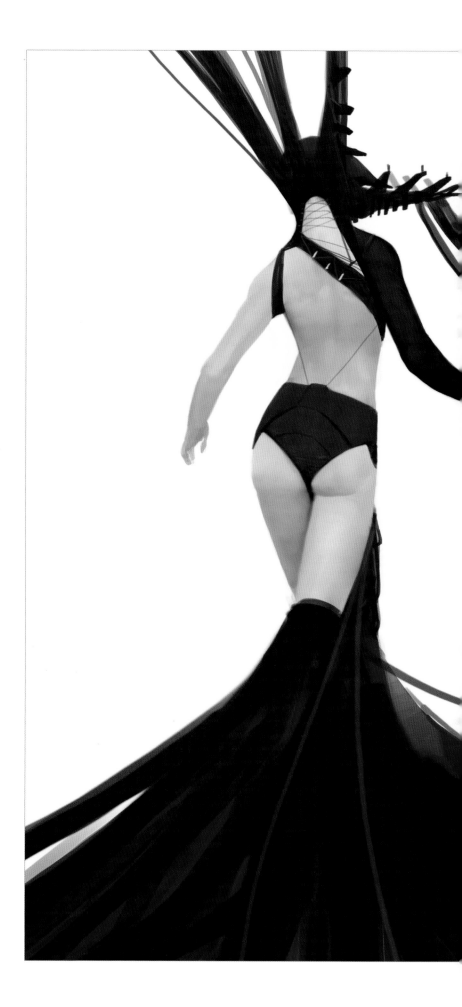

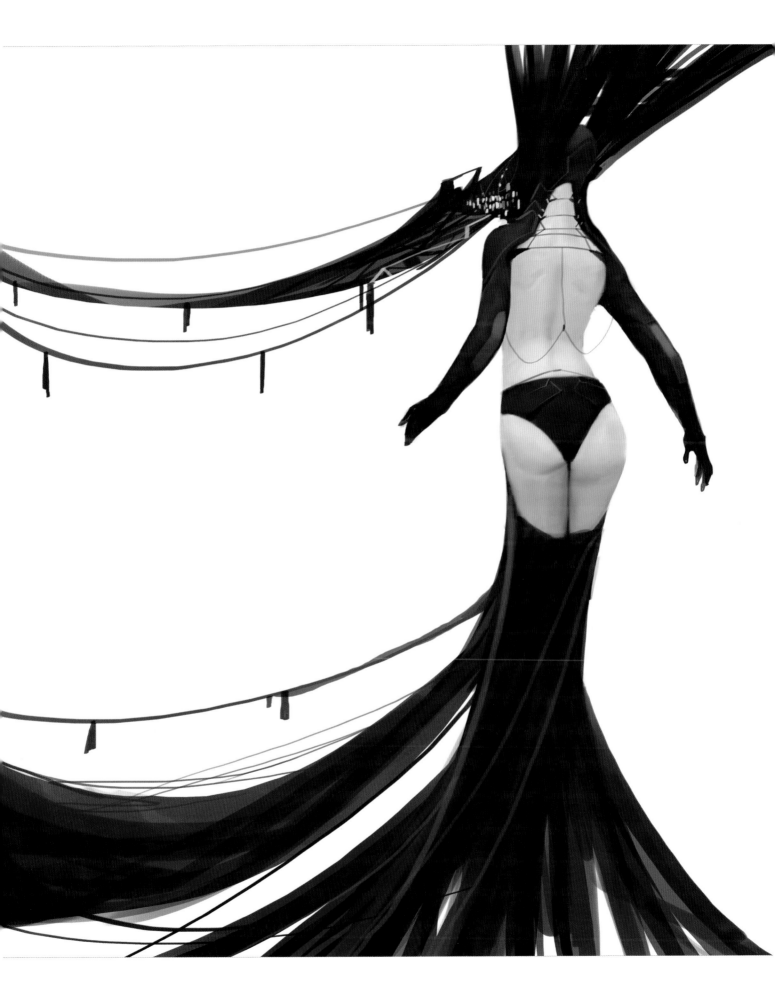

ASSORTED WORKS

The following are works I creating during the course of developing this book. I felt that these, as good as they may seem, were not ready or did not match the world I was building for *Heaven's Hell*. Though I still feel these are great to share.

Often you'll need to produce numerous drawings before even coming close to the idea that you had in mind. When I first began *Heaven's Hell*, I just drew whatever I felt was fun. Once I had a clear direction, it was important to keep that consistency throughout the project, and many of the works in this collection went by the wayside. But I hope you enjoy these paintings nonetheless, because each piece still reflects me, and the creation of each brought me closer to making this book a reality.

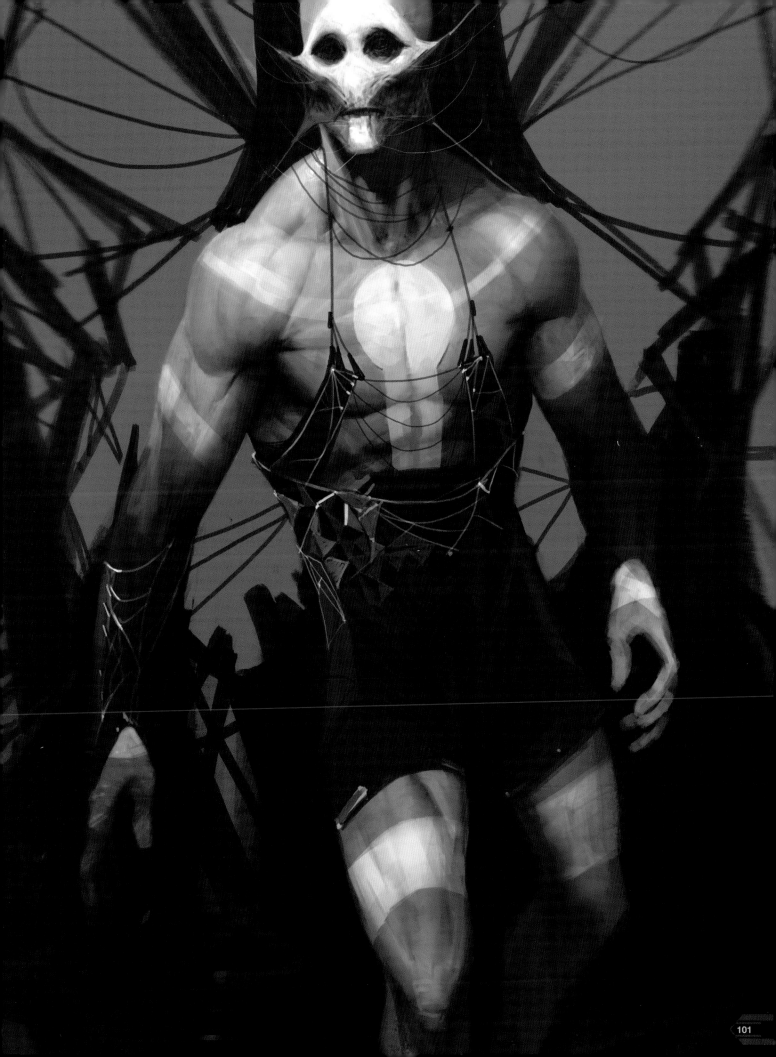

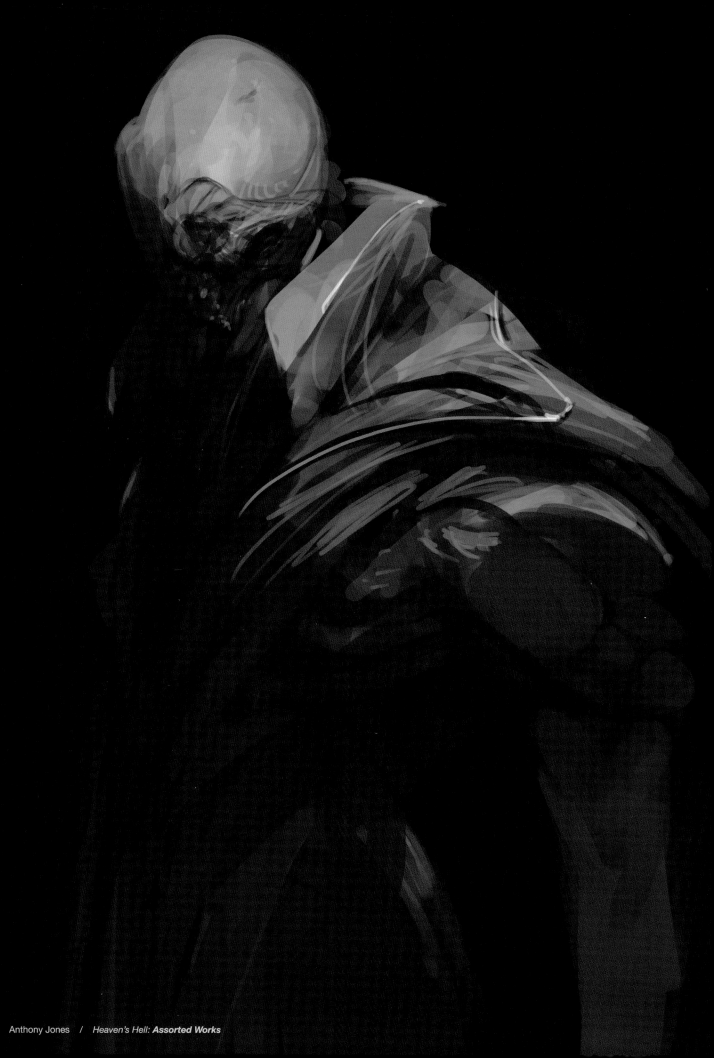

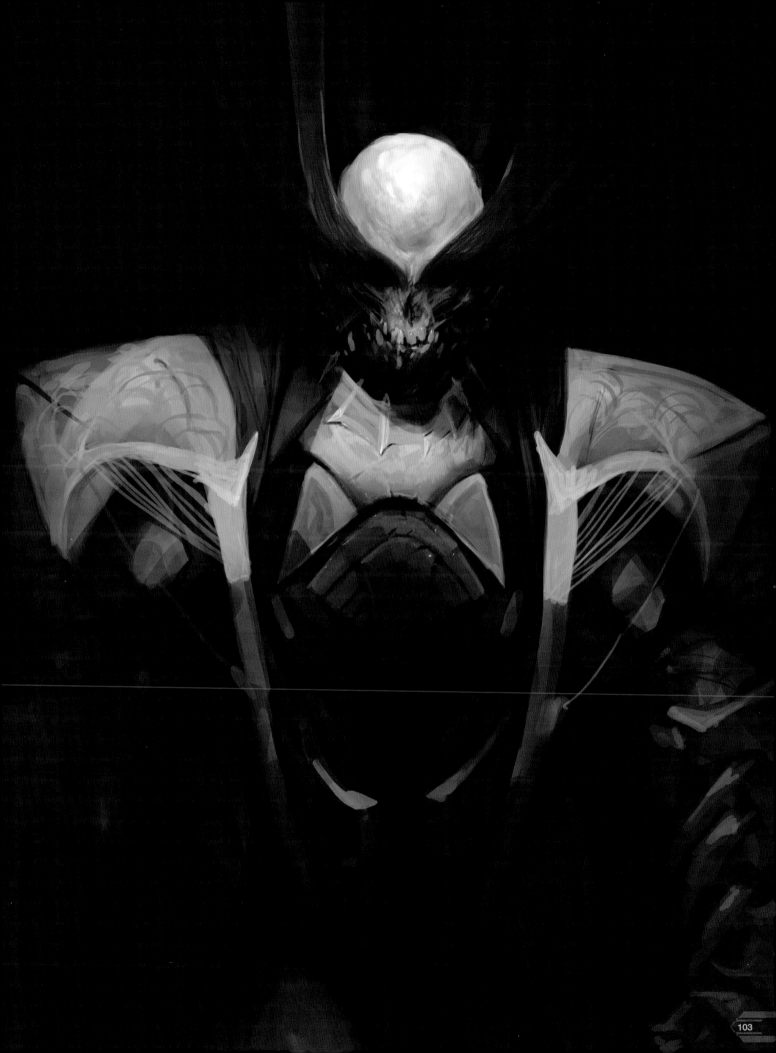

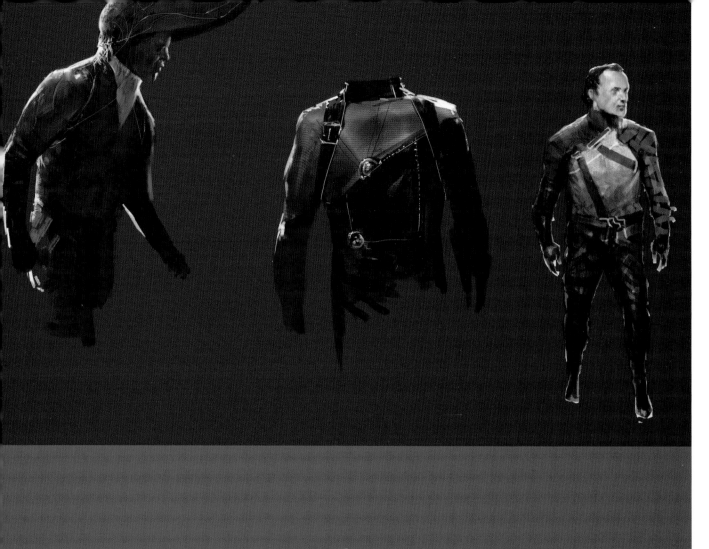

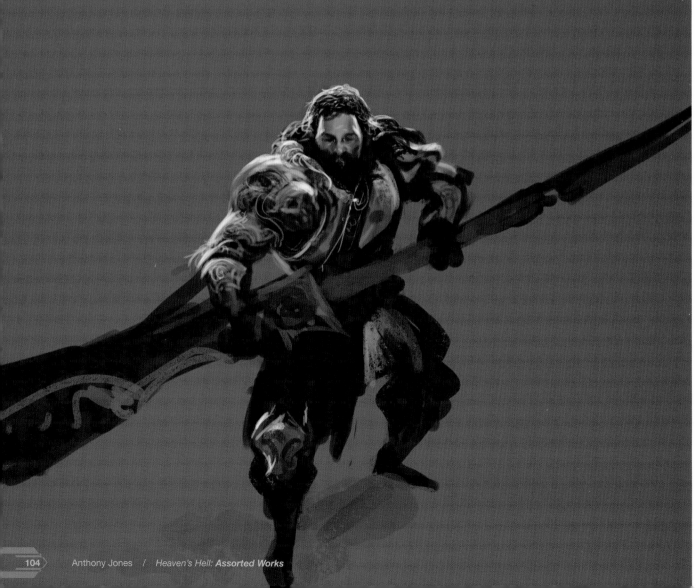

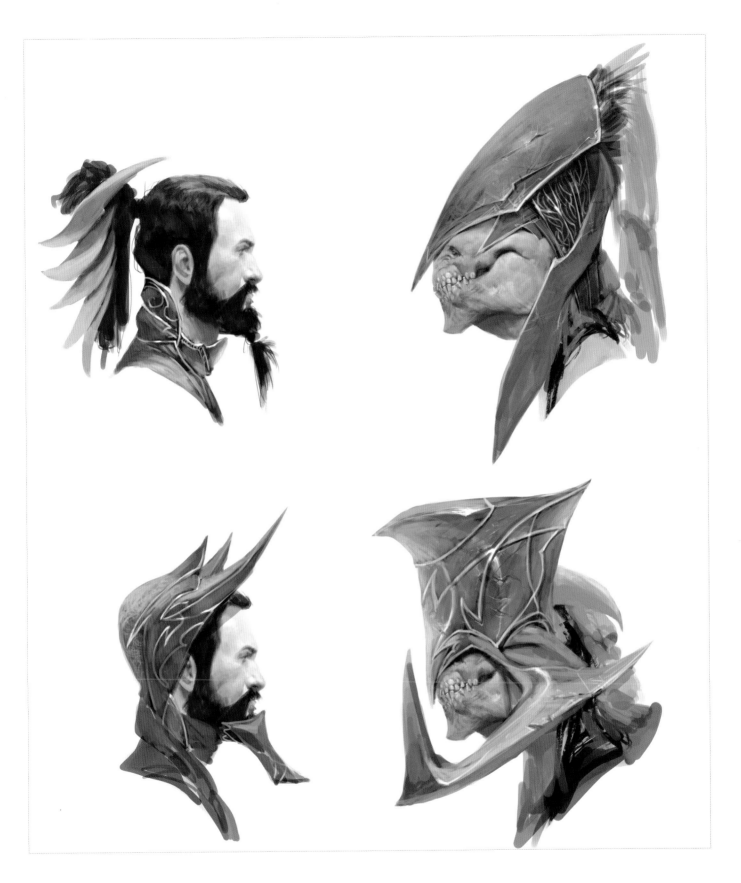

At the top of the opposite page are examples of suit designs I considered. They were the result of me learning how to paint differently, which made me like the designs in the first place. The bottom image also features a design I developed as I was testing brushes.

The above helmets and headpieces have a nice look to them, so I hope to see them added to *Heaven's Hell* later.

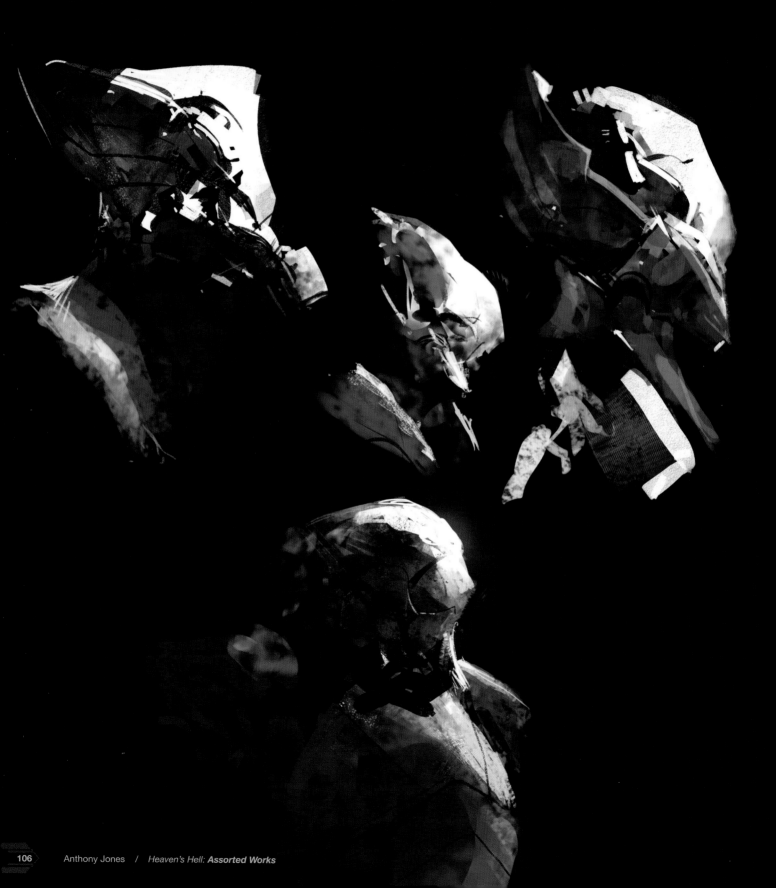

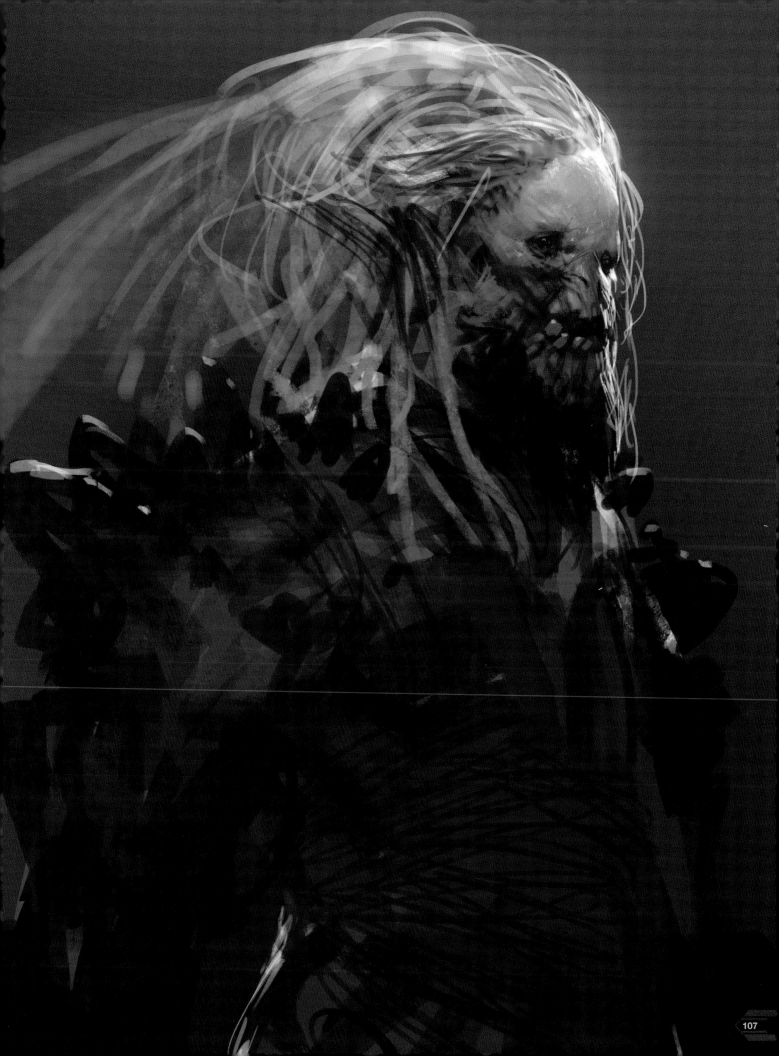

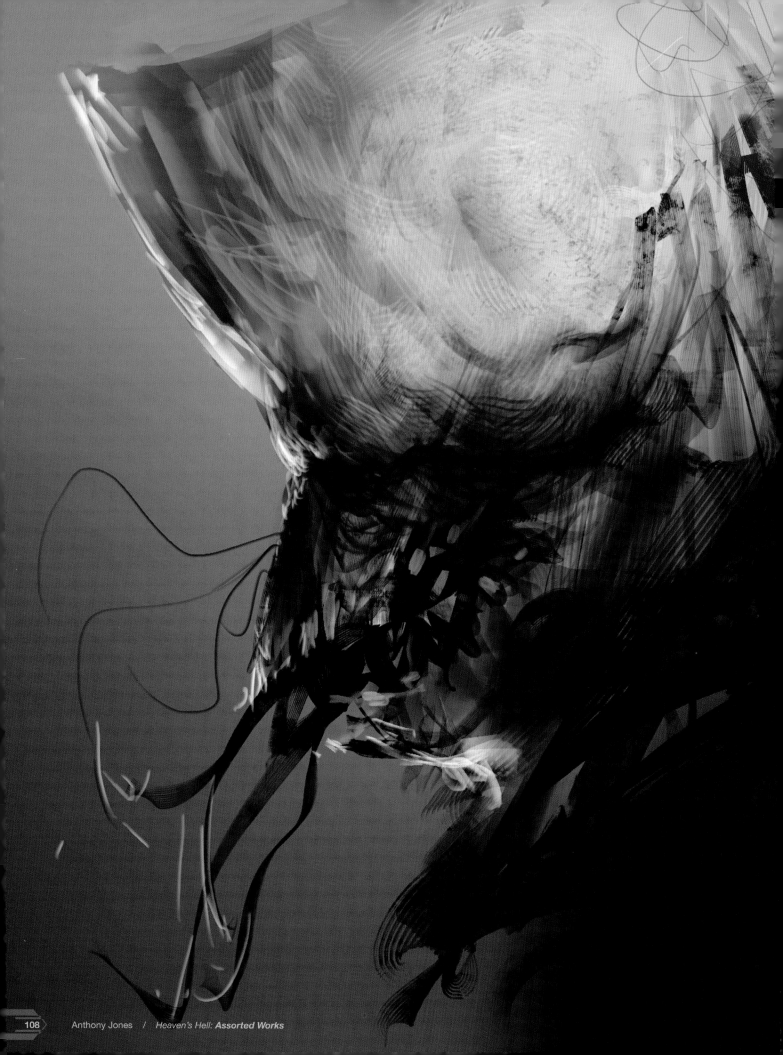

Anthony Jones / *Heaven's Hell: Assorted Works*

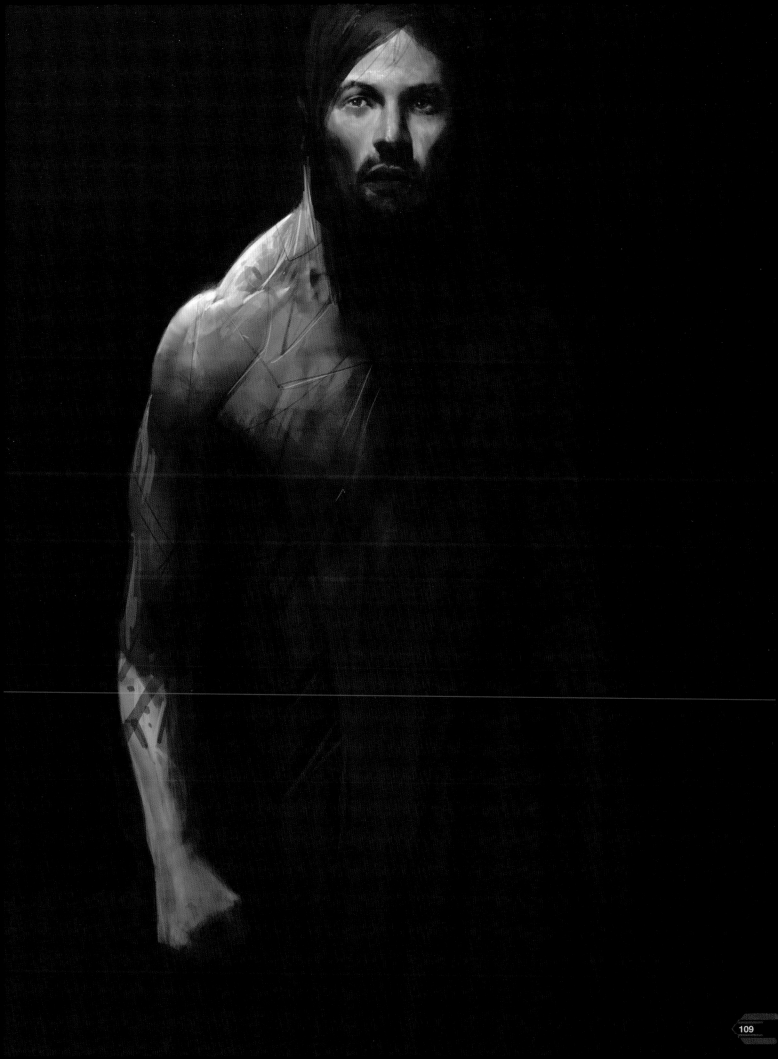

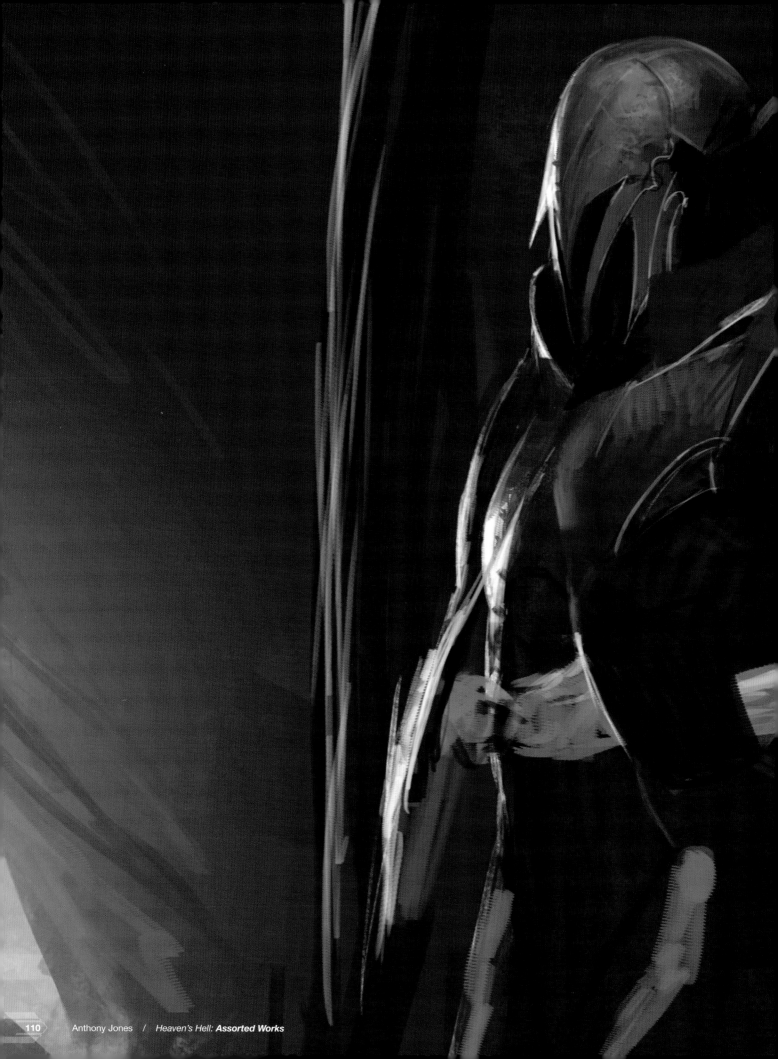

Anthony Jones / *Heaven's Hell: **Assorted Works***

This character is close to being done; I just need to figure out more of his lore and background, and to find out where he belongs among all the other characters I've developed for *Heaven's Hell*.

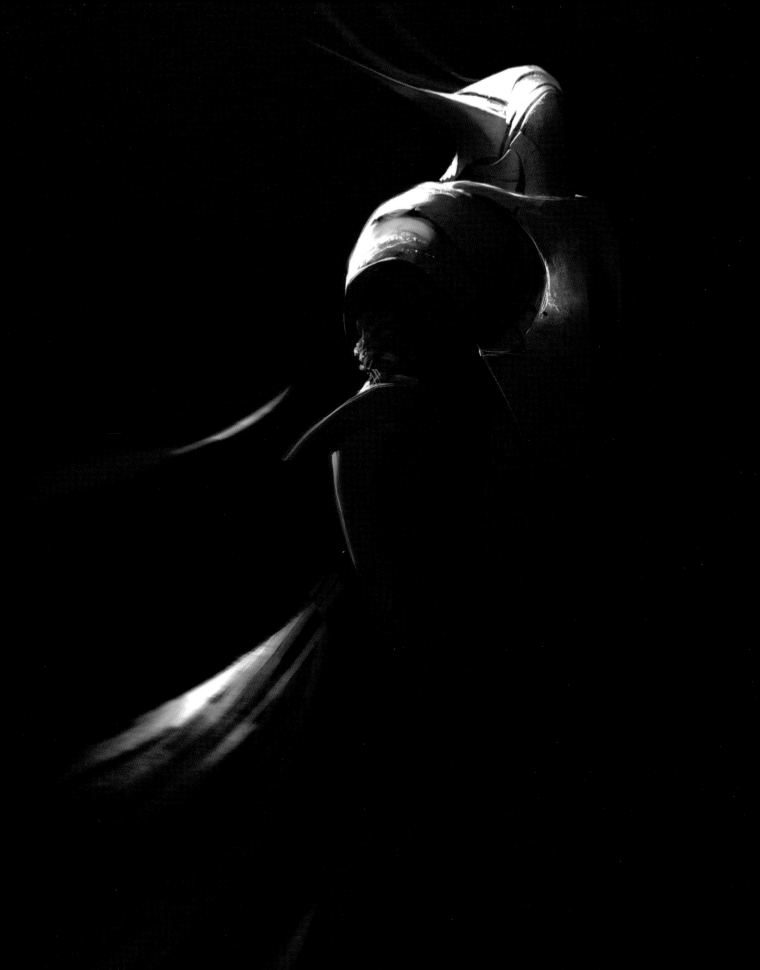

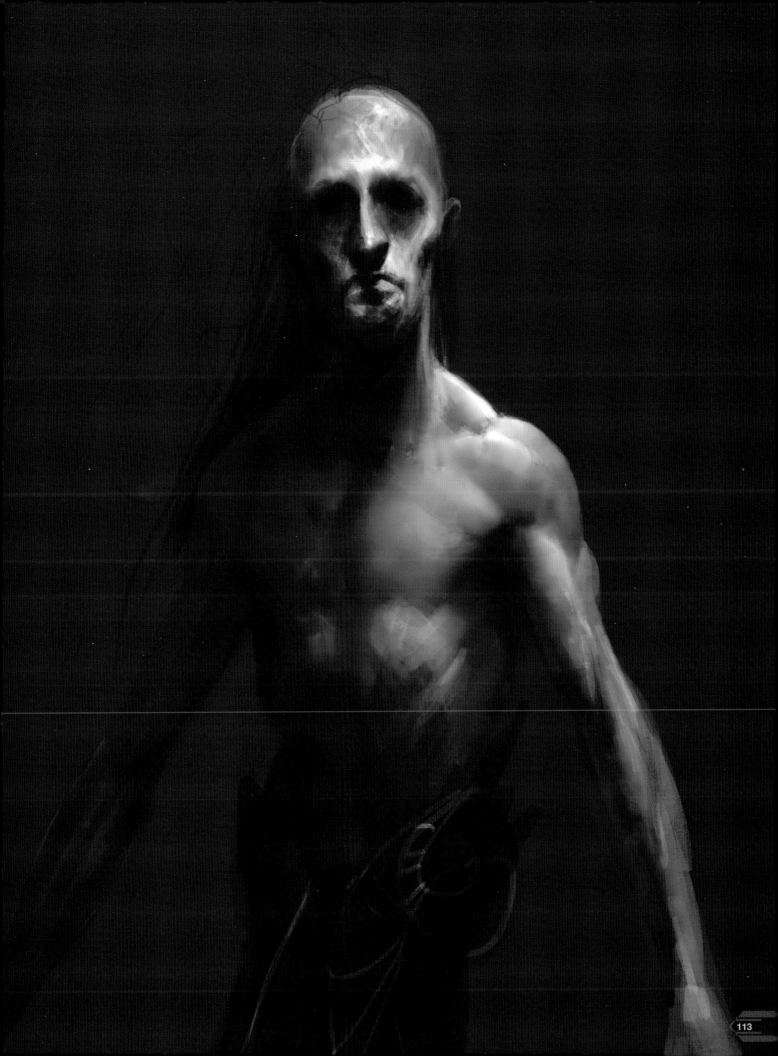

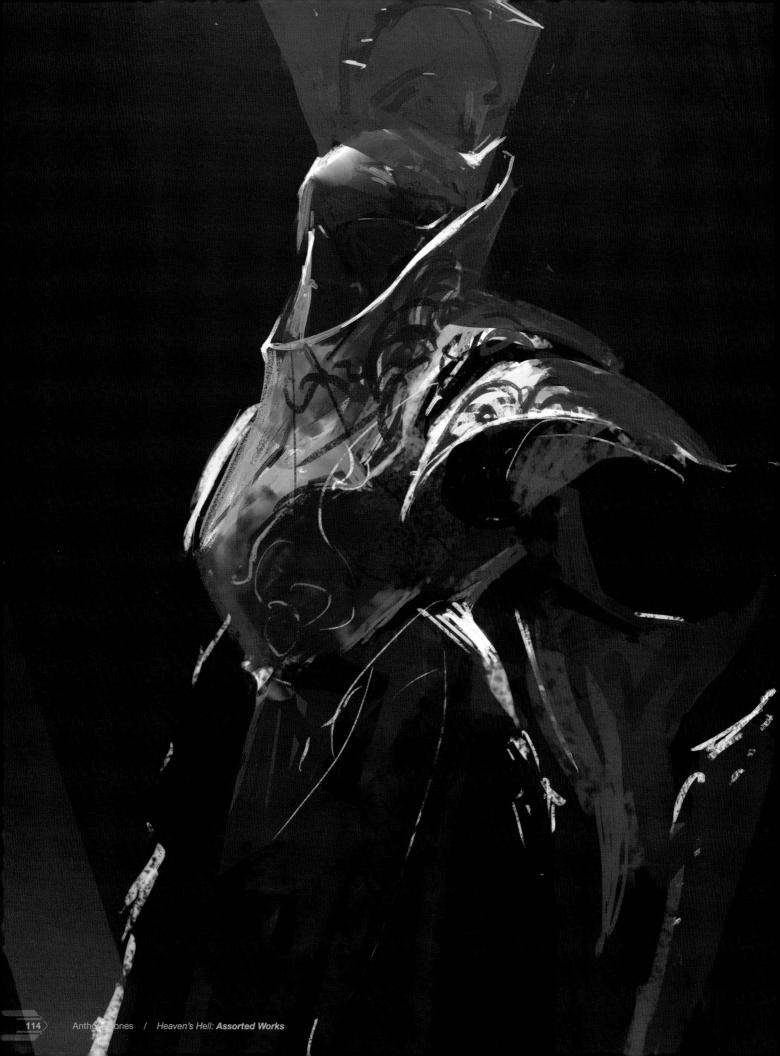

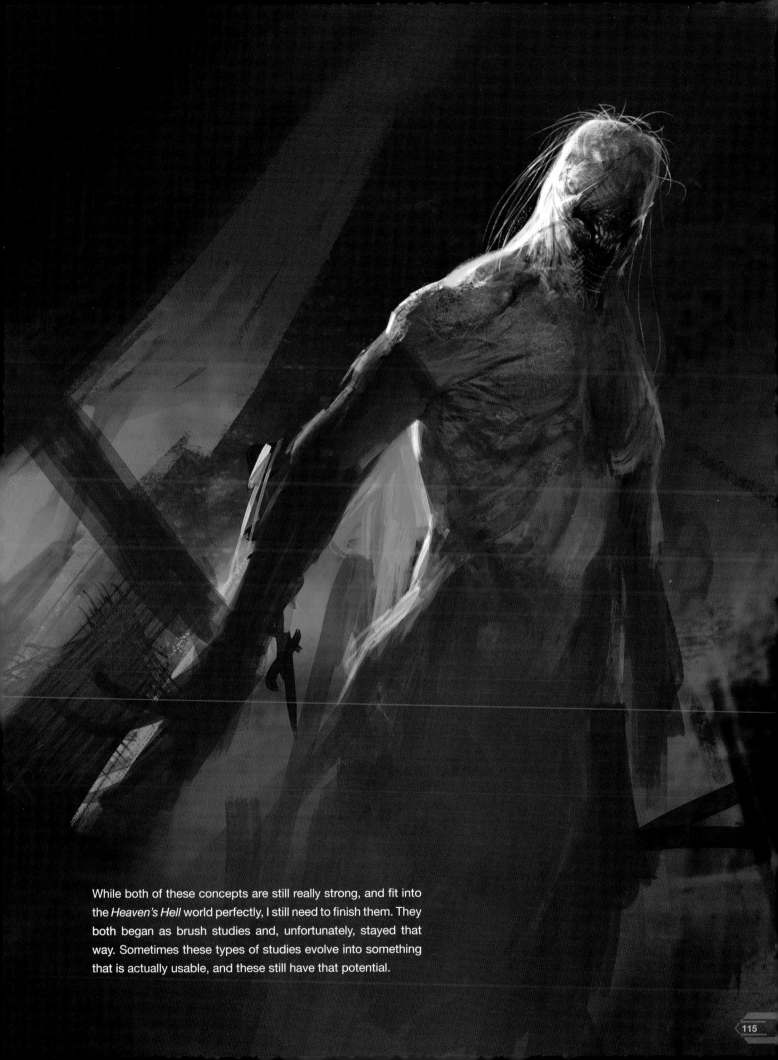

While both of these concepts are still really strong, and fit into the *Heaven's Hell* world perfectly, I still need to finish them. They both began as brush studies and, unfortunately, stayed that way. Sometimes these types of studies evolve into something that is actually usable, and these still have that potential.

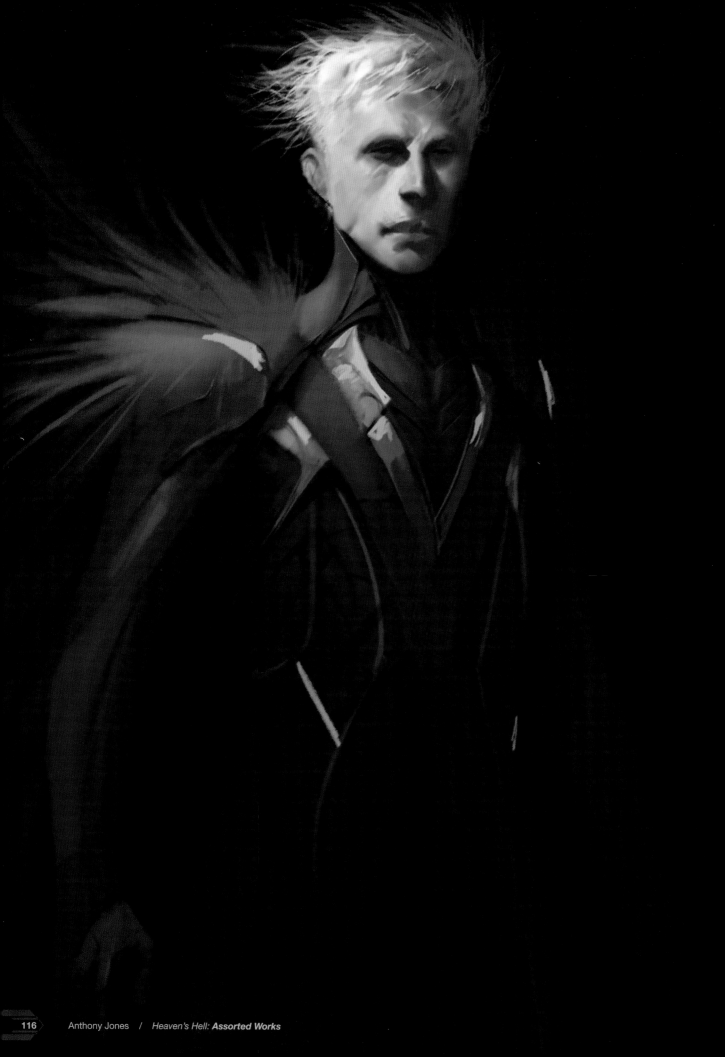

Anthony Jones / *Heaven's Hell:* ***Assorted Works***

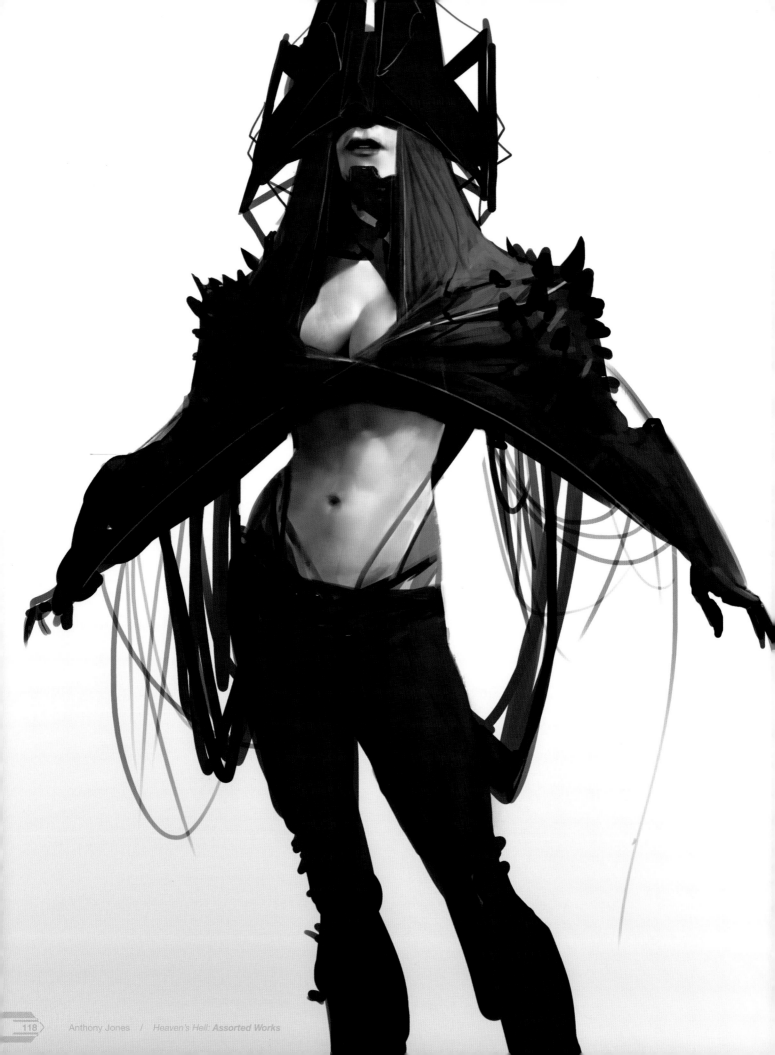

Anthony Jones / *Heaven's Hell: Assorted Works*

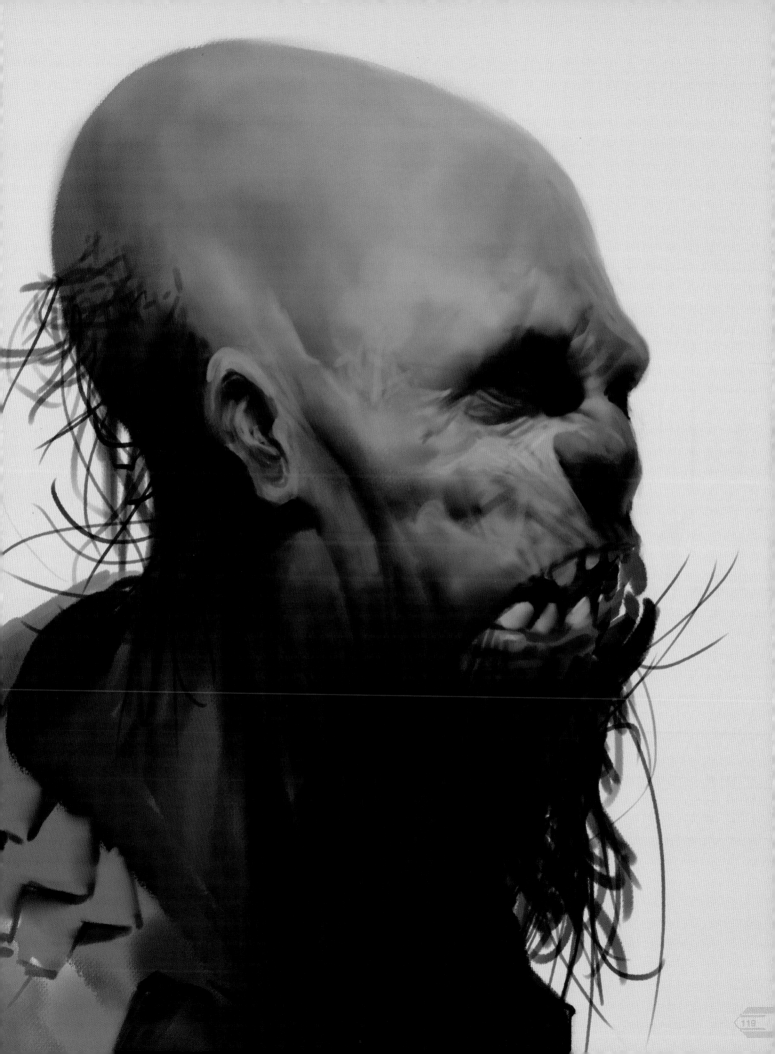

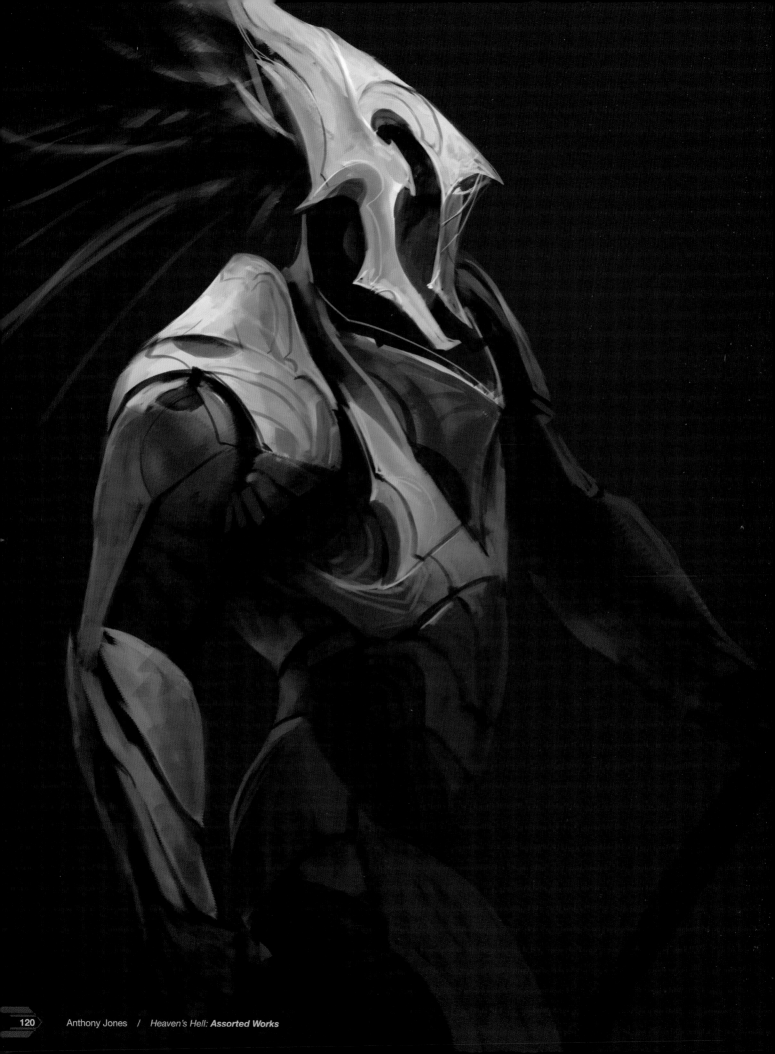

Anthony Jones / *Heaven's Hell: Assorted Works*

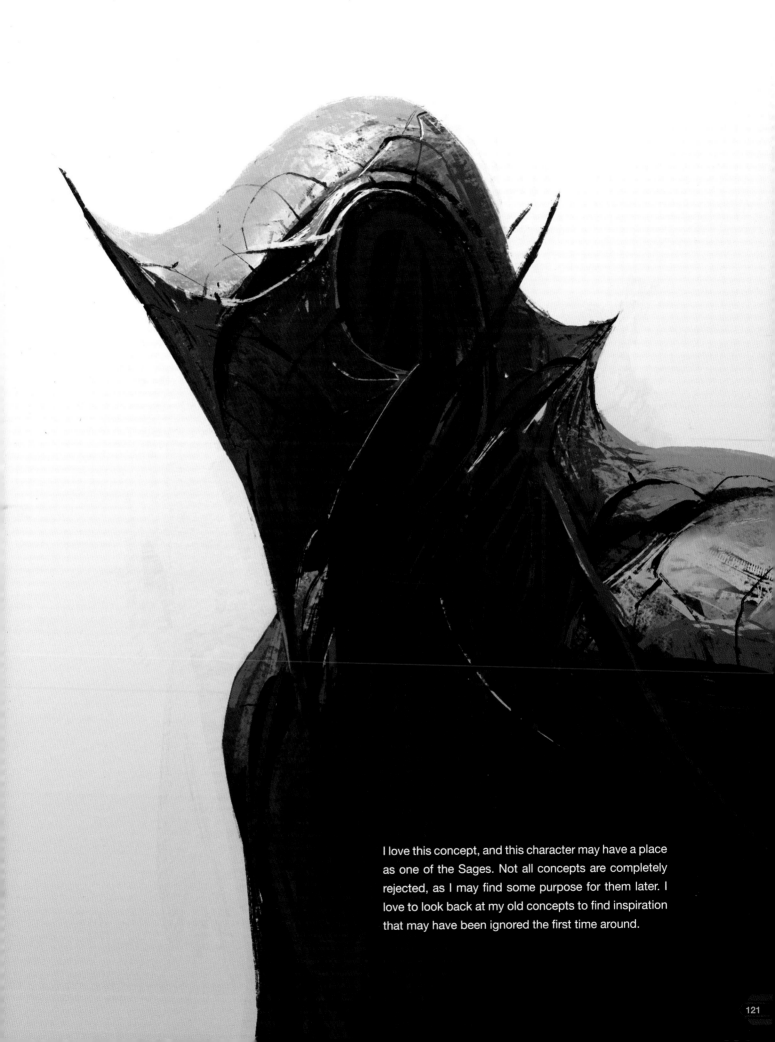

I love this concept, and this character may have a place as one of the Sages. Not all concepts are completely rejected, as I may find some purpose for them later. I love to look back at my old concepts to find inspiration that may have been ignored the first time around.

These final three images are concepts that I had for tormented souls in the afterlife. These images started out as fan art for *Silent Hill*, but slowly grew to become something else.

Repurposing concepts that were meant for something else is worth considering. Normally I wouldn't dabble in fan art, but I could be drawing or painting something, and it ends up looking like some quality fan art of another IP. I just go with it, because it clearly was in my subconscious waiting to get out, and sometimes images like these happen when I do allow for such exploration. Always be open to possibilities.

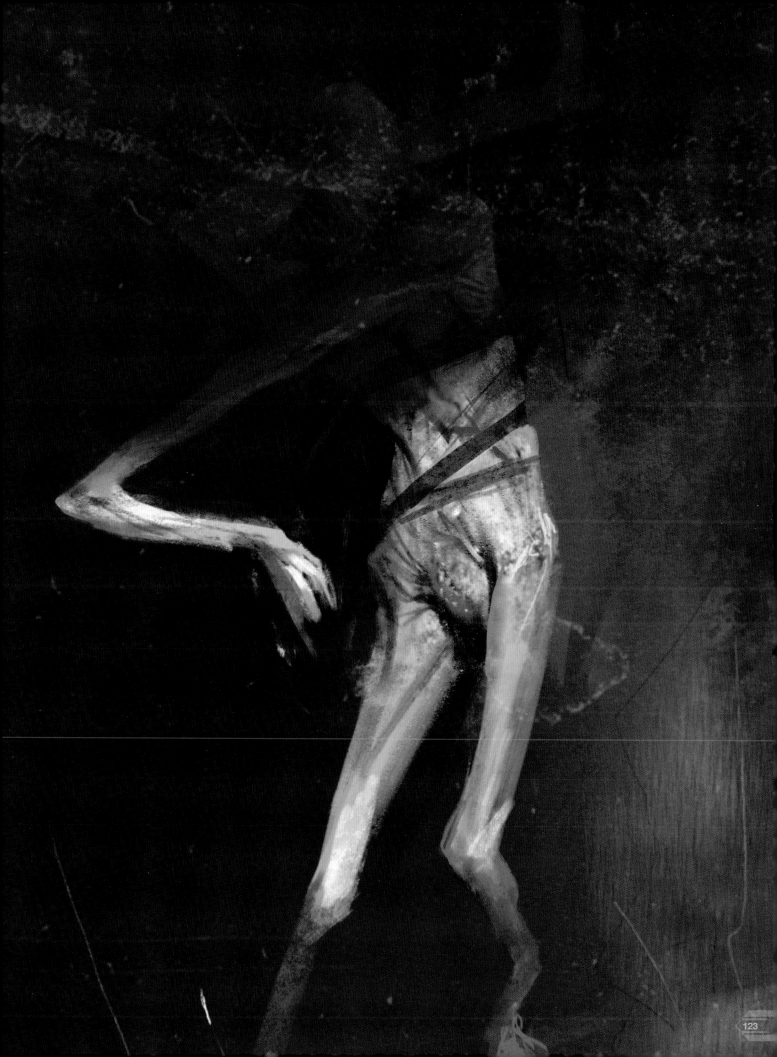

Anthony Jones / *Heaven's Hell: **Assorted Works***

WHEN YOU ARE DRAWING, LET YOUR BRAIN WANDER.

It will show you things that you have naturally
buried in your mind, and they will surprise you.

Aaron Dernley, Adam Fisher, Adam Luptak, Adam Nelson, Adam Richards, Adam Zacharias, Adrien Digiglio, Adryan Scicluna, Aksel Ludvigsen, Alan Klug, Alan Quinonez, Alan Tipp, Alec Maule, Alex Brock, Alex Chen , Alex Doroin, Alex Hartto, Alex Parker, Alex R. Kaulfuss Ph.D., Alex Smith, Alex White, Alexander Lebedev, Alexandra De Jesus Ferreira, Alexandra Ferreira, Alexandre d'Audiffret, Alexandre Zedig Diboine, Alexia Tryfon, Alexis Perron, Alfred Tsang, Ali Swei, Alon Tako Hacohen, Alvin Ho, Amanda Pavik, Amber Jam, Ameet Khara, Amy Fu, Anand Mistry, Andre Sutherland, Andreas Johansson, Andreas Werchmeister, Andrew Faithfull, Andrew Kane, Andrew Leesman, Andrew Martin, Andrew Robinson, Andrew Van, André Braghini, André Kishimoto, Andy Jung, Andy Nolan, Andy Park, Anne O'Berin, Anne Torstensen, Anthony Bianchi, Anthony Da Costa, Anthony Veilleux, Anton Kolyukh, Arnaud de Vallois, Arnd Empting, Aruna Inversin, Ash and Eli, Ash Thorp, Audre Schutte, Aurore Folny, Austen Mengler, Ayagaure Sanchez, Barbara LaPlaca, Barry Warner, Bastien Lecouffe Deharme, Ben Carlo Flores, Ben Franke, Ben Mulchin, Ben Thompson, Bernard Beneteau, Bethanie Yeong, Bien Q. Pham, Bill Tinney, Biolo Diseno, Blake Nichols, Brad Goldstein, Bradley Smith, Bradley Turner, Brandon Bell, Brandon Jones, Brandon Luyen, Bree Maldonado, Brendan Hanson, Brent Hollowell, Brett Bersche, Bretta Meyer, Brian Bedford, Brian Despain, Brian Fargo - Chief Tormentor, Brian Goodsell, Brian Kim, Britni Rauch, Bruno Biazotto, Bruno Cerkvenik, Bruno Naoki, Bryan Lie, Bryan Lockie, Bryan Morton, Bryant Koshu, Byron Satens, Caio da Costa Perez, Callum Atchison, Carla Buchanan, Carlos Alfonso Ponce Gallo Mireles, Caroline Holmes, Casey Hunt, Caution Lee, Cedric Anderson, Charles Van Ness, Charles White, Chase Toole, Chelsea Meissner, Cherie Davidson, Cheyne Crosby, Chor Guan Teo, Chris Bjors, Chris Born, Chris Castaldi, Chris Emond, Chris Hogan, Chris Lui, Chris Oliveri, Chris Scobee, Chris Szczesiul, Chris Weller, Christian Blom, Christian Lupp, Christopher Sims, Cindy Liu, Clarence Lansang, Cody Raiza, Colas Gauthier, Colin Bauer, Cordell Felix, Cornelius Hölz, Cory Conrad, Cory Irvin, Cory Jones, Courtland LaVallee, Cris Velasco, Crystel Land, Dacian Herbei, Dale Lamb, Damian Audino, Damian James, Damon Westenhofer, Dan Hong, Dani Naimare, Daniel Brandon, Daniel Chavez, Daniel Hong, Daniel K Kim, Daniel LuVisi, Daniel Orive, Daniel Platt, Daniel Stultz, Daniel Valerio, Daniel Walker Galdames, Daniel Warren, Danielle Demarest, Danny Gardner, Darrell S. Doswell, Darren Yeow, Darron Smith, Darylynn Homer, Davi Blight, David AC Mitchell, David Antonio Castro, David Bell, David Brumbley, David Chen, David Damian Fisher, David Dressman, David Martinez, David Pollack, David Richardson, David thrower, David "Deiv Calviz" Villegas, Dawn Carlos, Deana Lancaster, Denver Asence, Derek Cole, Derek Robert Gaffney, Derick Darby, Devon Dykwel, Diego Borellini, Diego Gisbert, Divina Magracia, Dolgopolov Evgeny Sergeevich, Dominic Law, Dominic Qwek, Donald Rowe, Doug Gregory, Douglas Laedtke, Durga Garcia, Dwayne Biddix, Dwight Bishop, Dylan, Dylan Rinker, Dzu Nguyen, Edgar Mendez, Edidiong Udo, Edward Lillywhite, Eli Curtz, Eli Wilde, Elijah Podell, Elizabeth Crissey, Emerson Tung, Emil Friesenhahn, Emiliano Deificus, Eric Alebeard McAxendorf Robertson, Eric Berthelette, Eric Damon Walters, Eric Durante, Eric Kenji, Eric Kozlowsky, Eric Son, Eric Yip, Erica Fletcher, Erik Beckmann, Erik Jakobsson, Erik Ly, Erik Reiter, Eva Widermann, Evan Hilborn, Evan Raynor, Evan Squire, Fabien Jacques, Fahrija Velic, Faruk Hussain, Federica Litrico, Fei Ou, Feldman Jeremie, Felipe Escobar, Felix Embree, Felix Yuan, Fergus Dupleix, Fernando Fernandes, Fernando Gomez, Fernando Quintão de Lacerda, Ferra Alexandre, Forrest Imel, Francesco Graziani, Francisco Javier, Frank Beddor, Frank Mastromauro, Frank Tzeng, Frankie Perez, Franklin Crosby, Franklin Lei, Frederic Daoust, Gabriela Margarita De Jesus, Gabriele Toffoli, Gary J Smith, Gavin Brooks, Ge Zhang, Geo Aquino, George Richardson, Gerardo Valerio, Gibson Radsavanh, Girma Moges, Glauco Longhi, Glenn Cowley, Gloria Shih, Gray Eyes, Greg Lohr, Guido Leber, Guillaume Franco, Guo Junwei, Gurdeep Singh, Guy Davis, Han Davidson, Hannah JS Davis, Hans Olo, Heino Brand, Henry Peltokangas, Hernan Flores, Howie Lee, Hugh O'Donnell, Huy Dinh, Håkan Frisk, Ian Ameling, Ian Barker, Ian Core, Ian Hirschfeld, Ignacio de la Calle, Irshad Karim, Isabella Chen, Israel A. Carrion, Ivan Eskandari, Ivan Kochetov, Jack Eaves, Jack Heavenor, Jack Lau, Jacob Juan, Jacobiahs Jay, Jake Bullock, Jake Madrid, Jake Opperman, Jakob Burgos, James Becker, James Marsano, James Perkins, James Wu, James Zapata, Jan Urschel, Jane Lim, Jared Jones, Jared Levin, Jason Brongel, Jason Busby, Jason Hall, Jason Holt, Jason Jones, Jason Oren, Jason Quinlan, Jason Rosen, Jason Sperber, Jawad Alshakhs, Jayna Pavlin, Jeanne Oconnell, Jeff Clendenning, Jeff Hindsbøl Hansen, Jeff Lofland, Jeff Obrien, Jeff Voss, Jefferson Wand, Jehan Choo, Jelena Senicic, Jennifer Lim, Jennifer McCann, Jennifer Mealing, Jens Kuczwara, Jeremy Bastian, Jeremy Fine, Jeremy Freeman, Jeremy Hancock, Jeremy Kear, Jeremy Leo Bolton, Jeremy Saliba, Jesse James Bonelli, Jesse James Younger, Jessica Dru, Jessica Huffman, Jessica LaRusso, Jessica Lynn, Jessica "Jess"Jerome, Jessie Lam, Jez Clement, Jim McAllstr, Jimmy Vong, Joe MacCarthy, Joe Peterson, Joe Sullivan, Joel Wenham, Johan Broberg, Johan Grenier, Johann J Aza, John Brassell, John Bridges, John Cipriani, John Mahoney, John Picacio, John Porter, John Trotter, Johnny Shen, Jomaro Kindred, Jon A Baker, Jon Dunham, Jon Jacobs, Jon McConnell, Jonathan Aguillon, Jonathan Kang, Jonathan Kuo, Jonathan Larson, Jonathan Lindblom, Jonathan Martin,

Jonathan Reis, Jordan Ewing, Jordan Widiker, Jose Acebes, Jose Martinez, Joseph Urena, Josh England, Josh Hagen, Josh Hardie, Josh Holmes, Josh Stobbs, Joshua Calloway, Joshua Meehan, Joshua Rogers, Josu Solano, Josue Mariscal, Joy Gomi, Juan Gabriel Gil, Jukka Rajaniemi, Julia Lichtblau, Julius Milto, Jun Xu, Jussi Myllyluoma, Justin A. Joson, Justin Kim, Justin Kimball, Justin Miracle, Justin Owens, Justin Schut, Justin Wong, Jörn Zimmermann, Kai Chong Christopher Du, Kalle Noring, Karl Schulschenk, Kassandra Vasquez, Kate Pfeilschiefter, Katelyn Schmidt, Keith Bartness, Keith VanZant, Keith Williams, Keith Zoo, Kelsey Rogers, Kelvin Moore, Kendrick Lepage, Kenny Cho, Kerry Jones, Kevin Jones, Khyzyl Saleem, Kim Jenkinson, King Hao Chen, Kirsty Stewart, Klas Rönnbäck, Kolby Jukes, Konstantin Leontyev, Kurt Papstein, Kwangho Myung, Kyle baerlocher, Kyle Sewnarain, Larry Charles, Lauren Saint-Onge, Laurie Goodridge, Lee Joyner, Lee Tyler, Lenny Shi, Leonardo Menezes, Lewis Goddard, Lie Setiawan, Lilium Sunday, Lim Boon Keong, Linus Forsell, Liz Kirby, Liz Steinworth, Lizette Ruezga, Logan Dwight, Logan Feliciano, Luca Cauchi, Luciano Fernandez, Luis Gama, Luke Tarver, Lyle Moore, Maciej Kuciara, Maggy Lisakowski, Maisie Yang, Marc Robert, Marcel Mateo, Marco Alvares, Marcus Luk, Marcus Penn, Marian Huber, Marisa Erven, Marius Bota, Marjorie-Ann Lacharite, Mark Buckley, Mark Molchan, Mark Venables, Mark Whyte, Markus Oljemark, Marshal Uhls, Marta De Andrés, Martin Kepler, Martin Zetter, Marvin Li, Maryanne Carman, Mateus Rocha, Mats Morken, Matt DiVietro, Matthew Bramante, Matthew Cotton, Matthew Dudley, Matthew Edwards, Matthew Eng, Matthew Ibbotson, Matthew Manard, Matthew Marler, Matthew Newhart, Matthew Walker, Matthew Zikry, Mauro Rodriguez III, Max Barrow, Max Davenport, Max Jarl Christiansen, Max Loegler, Maximilian Gordon Vogt, McLean Kendree, Melinda Davidson, Melissa Encinas, Melissa Forde, Melvin Chan, Michael Ackerman, Michael Adams, Michael Alexander Giangrasso, Michael Ardrey, Michael Bo Gyu Chae, Michael Brunner, Michael C Hayes, Michael Cacciamani, Michael Carter Jr., Michael Davini, Michael Loos, Michael Olszak, Michael Ponschke, Michael Tiscareno, Michael Tran, Michal Ivan, Michel Quach, Michele Ann Murtaugh, Michelle Quisenberry, Miguel Guerrero, Mikael Quites, Mike Cech, Mike Corriero, Mike Craig, Mike Guiang, Mike Jasnowski, Mike Jones, Mike Lim, Mikko Sinisalo, Mingjue Chen, Mitchell Malloy, Monica Munster, Monique Vasquez, Moritz Lipp, Natalie Becker, Nate Hallinan, Nate Miller, Nath Kai, Nathan Martin, Nathan Vergin, Nathaniel Moody, Negrea Alexandru, Neil Davidson, Nelson Wah, Neville Page, Nicholas De Spain, NIcholas Jasper, Nicholas Miles, Nick Slough, Nick Starr, Nicolas Camiade, Nicolas Rouanet, Nicolas Siner, Nicolas Thibodeau, Nikita Chan, Nikola Odic, Norris Lin, Olav Telneset, Oliver Ryan, Olivia del Bufalo, Omar & Sheila Rayyan, Ori Bengal, Oscar Sjöstedt, Oskar Johansson Möller, Oussama Agazzoum, Patrick Barron, Paul Egan, Paul J Mendoza, Paul Kwon, Paul LeBlond, Paul Quinton, Paul Round, Pavel Mamichev, Pelat Federico, Peter Amthor, Peter Lee, Peter Mohrbacher, Peter Wan, Petter Strætkvern Fossum, Phil Holland, Phil Wang, Philip Eisner, Philipp Glietsch, Pierpont, Pierre Nilson, Pierre Raveneau, Polina Hristova, Pontus Ullbors, Quinlan Septer, Race Oswald, Rachael Rossman, Rachel Lee, Radha Mistry, Rafael Batista, Randall Draper Jr, Raphael Nadeau, Raphael Phillips, Raul Osorio, Ray Kallmeyer, Ray Newland, Rebecca Helm, Rebecca On, Rebecca Tsang, Reid Southen, Reyhan Sadaka, Ricardo Carvalho, Richard Parkins, Richard Tran, Rick Howard, Rick Wharton, Rob Nesler, Rob Shields, Rob Vink, Robert Fowler, Robert Sevilla, Robert Silva, Robert-Ovidiu Chilarez, Roberto Garcia, Robin Chyo, Rochelle L. Burrows, Rocky Smith, Rodger Pister, Rodney Dollah, Rodolfo Hernandez, Rodolfo Perissé Rocha, Ronwaldo Francisco, Ross Brewer, Roy Cowing, Roy Gee, Rudy Massar, Russell Jones, Rustam Hasanov, Ryan Anderson, Ryan Kitelinger, Ryan Ross, Sally Rogerson, Sam Balzer, Sam Brown, Sam Hetzel, Sam Rowan, Sam Tung, Samuel Freshwater, Samuel Tung, Sarah Jean Partington, Savanna Redman, Scott Bromander, Scott Denton, Sean D. Whaley, Sean Lambert, Sean Thurlow, Sean Walling, Serge Astahoff, Shane Bouthillier, Shannon Beaumont, Shaun Bryant, Shaun Kachellek, Shawn Kirsch, Shawn Marier, Shawn Thomas, Shelley Cao, Shreya Shetty, Shun Yao Xie, Sidney Lugo, Simon Kidane, Simon Rudberg, Siscu Díaz, Solomon Gaitan, Stanley Onyewuchi, Stefan Einarson, Stefan Manolov, Stephen Halleck, Stephen Oakley, Steve Courtney, Steve Crespo, Steve Longhurst, Steve Luna, Steve Palmerton, Steven Cresswell, Steven Oswin, Steven Raaymakers, Stevie Coelho, Susan Murtaugh, Syid Massiah, Tamara Salatova, Tan Li Xiong, Tanya Gomelskaya, Tara Bayliss, Tara Smith, Tatiana Vetrova, Teck Lee Tan, Terry Dam, Terry Wolfinger, Theo C Aretos, Thibauld Dallenne, Thomas Bauer, Thomas Brillante, Thomas Church, Thomas Nguyen, Tim Diaz, Timothy Anderson, TJ Wright, Toby Grauberger, Toby Lewin, Tom Cushwa, Tom Ireland, Tom Krieger, Tomas Overbai, Tony Peterson, Tony Tang, Trang Huynh, Tris Baybayan, Tyler Breon, Tyler Chow, Tyler Geosano, Tyler Ryan, Valeri Che, Veronica Lynn Harper, Victor Mosquera, Vincent-Michael Coviello, Vinny Vincent W, Vladimir Boyko Kuznetsov, Warren Marshall, Wei Chen Mark Wang, Wendell Nesbit, Wesley Burt, Wilbur Liang, Will Gist, Will Harris, William McFarland, Wook Hyung Lee, Xi Jielin, Yap Kenn Rhoung, Yarey Cuevas, Yekaterina Bourykina, YemYam, Yen-Ren Wang, Yinghao Chan, Yong June Shin, Yong Yi Lee, Yves Briquet, Yvonne Chung, Zach Hagen, Zach Oldenkamp, Zachariah Briggs, Zachary Berger, Zachary Hughes, Zachery Glaviana.

ABOUT THE ARTIST

Anthony Jones has worked as an artist in the entertainment industry since 2008. He has worked for several notable companies over his career, including Sony, Blizzard Entertainment, Paramount, Western Costumes, Applibot, Wizards of the Coast, and Hasbro. But he is most proud of his role as a teacher, helping aspiring artists finesse their skills, as well as providing them a venue where they can showcase their work, through his company, Robotpencil.

See more of Anthony's work at:

robotpencil ✏

www.robotpencil.net

Why did you create the Heaven's Hell world?

At first it was a challenge to myself. Can I draw a concept in one hour? Then it grew to become a world with real characters and a real setting. I made no attempt to expand it until I saw the amount of love and passion people had for the paintings. So I began to write a story, draw a world, and build from there. I think sometimes having a fully realized idea too early on can deter a lot of people to start, but for me I didn't have something like that. It definitely became difficult to finish when I increased the stakes!

Where did you draw inspiration for the various characters and their attire?

I love extreme, high-concept fashion design, black-and-white photography, and monsters. So I just put those ideas together as I developed the characters. I should note that I only paint in grayscale because it keeps my attention focused on the pure aesthetic design and forms. Color can distract you, depending on what you prefer, but values are universal. That is why I love to stay there, in grayscale; it's a bit more objective in its simplicity.

As for the clothing, I love lots of cloth and fabric mixed with flesh and metal. Playing with contrast is my greatest strength and something I see in my favorite work. I'm inspired by tons of great art and imagery, but to list a few of my influences, they would be John Singer Sargent, J.C. Leyendecker, and Alexander McQueen.

What do you hope that your fans will take away from Heaven's Hell?

To follow your creative aspirations, though it may take a lot of time and effort. That being original or pushing yourself to where no one tells you to go is not always encouraged, or seem possible, but it is within reach. The art that I draw is mostly for me, and what I find interesting. My clients usually hire me for the type of work I already love to do, and that is also very exciting. Remember that finding who you are as an artist takes time, and nothing should be rushed, but still be pursued. I have no other intention than for people to be inspired by my work to build their own worlds, once they are done looking at mine.

To order additional copies of this book and to view other books we offer, please visit: www.designstudiopress.com

For volume purchases and resale inquiries, please email:

info@designstudiopress.com

Or you can write to:

Design Studio Press
8577 Higuera Street
Culver City, CA 90232

Telephone: 310.836.3116
Fax: 310.836.1136

To be notified of new releases, special discounts, and events, please sign up for the mailing list on our website, join our Facebook fan page, or follow us on Twitter:

 facebook.com/designstudiopress

 twitter.com/DStudioPress